Life As Once We Knew It

Images of a Lost Human Epoch
By
Annie Leibovitz

First Published Worldwide as an
Ebook and Printed Volume in 2014

Photographs and Text © 2014
by
Annie Leibovitz
All Rights Reserved

Edited by Alicia Gunderne

Designed by Natasha Hill

Preface

In the beginning was the world, and the world was good. We as Mankind roamed the earth in search of things and found things to please us. But we lost our link with Mother Earth and uprooted ourselves from her. Never to return?

Within these pages I have depicted humans as part of the Natural World – as once we were.

I hope you will see within these pages the purity and invigoration of the Life Force that made you.

Annie Leibovitz New York 2014

Introduction

Annie Leibovitz is a portrait photographer She aims to express within this new collection the flowing lines and deification of the human body as seen in classical Greek and Roman sculptures

The pictures in this album were shot in England USA and Greece between 2006 and 2013

Annie Leibovitz lives in New York and London

Alicia Gunderne the editor of this album is a creative director for Framepool Photo Library in Munich Germany

Natasha Hill the designer of this book is a photographic editor and designer in her first year of study toward an MA in photography at the University of Los Angeles in California USA

The Formation of Structure

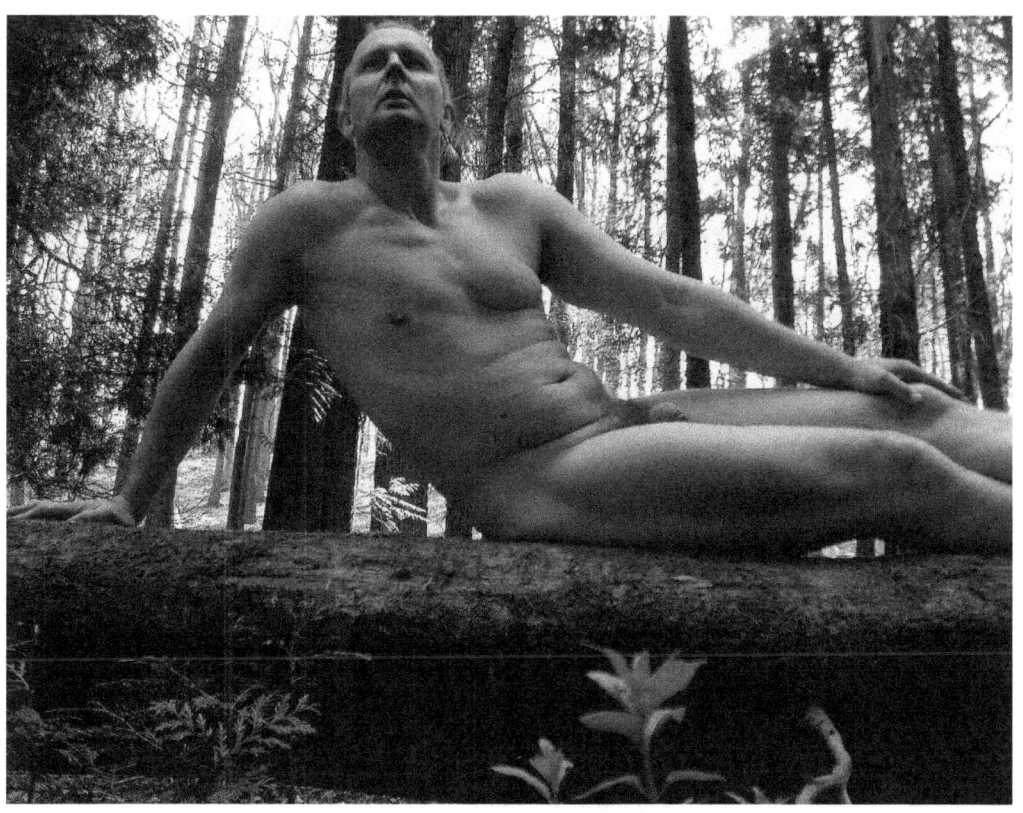

Will

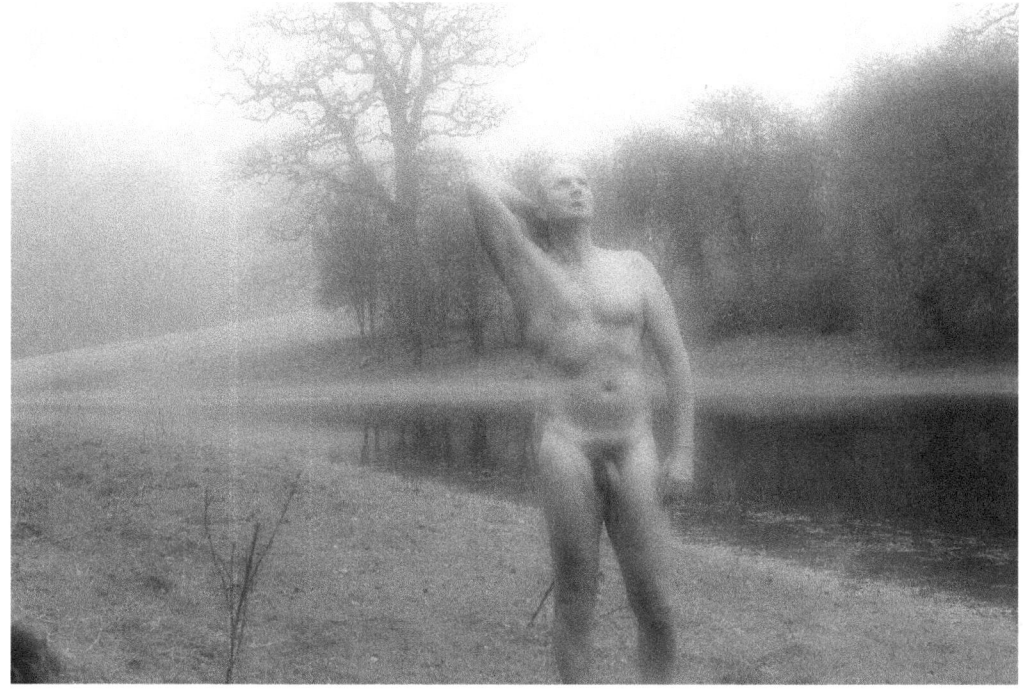

Configuration

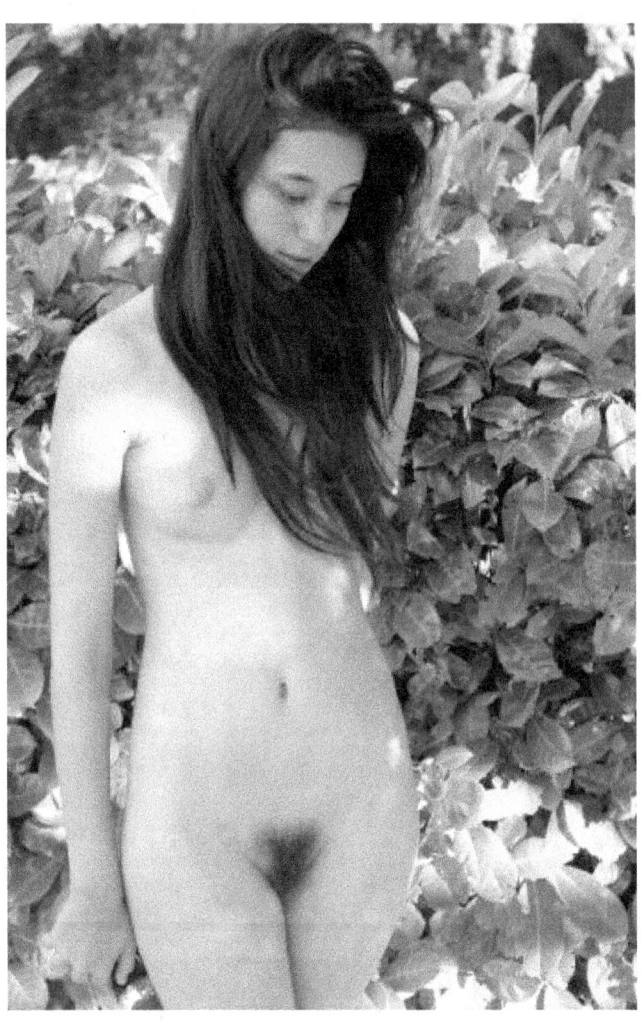

Heart or Darkness

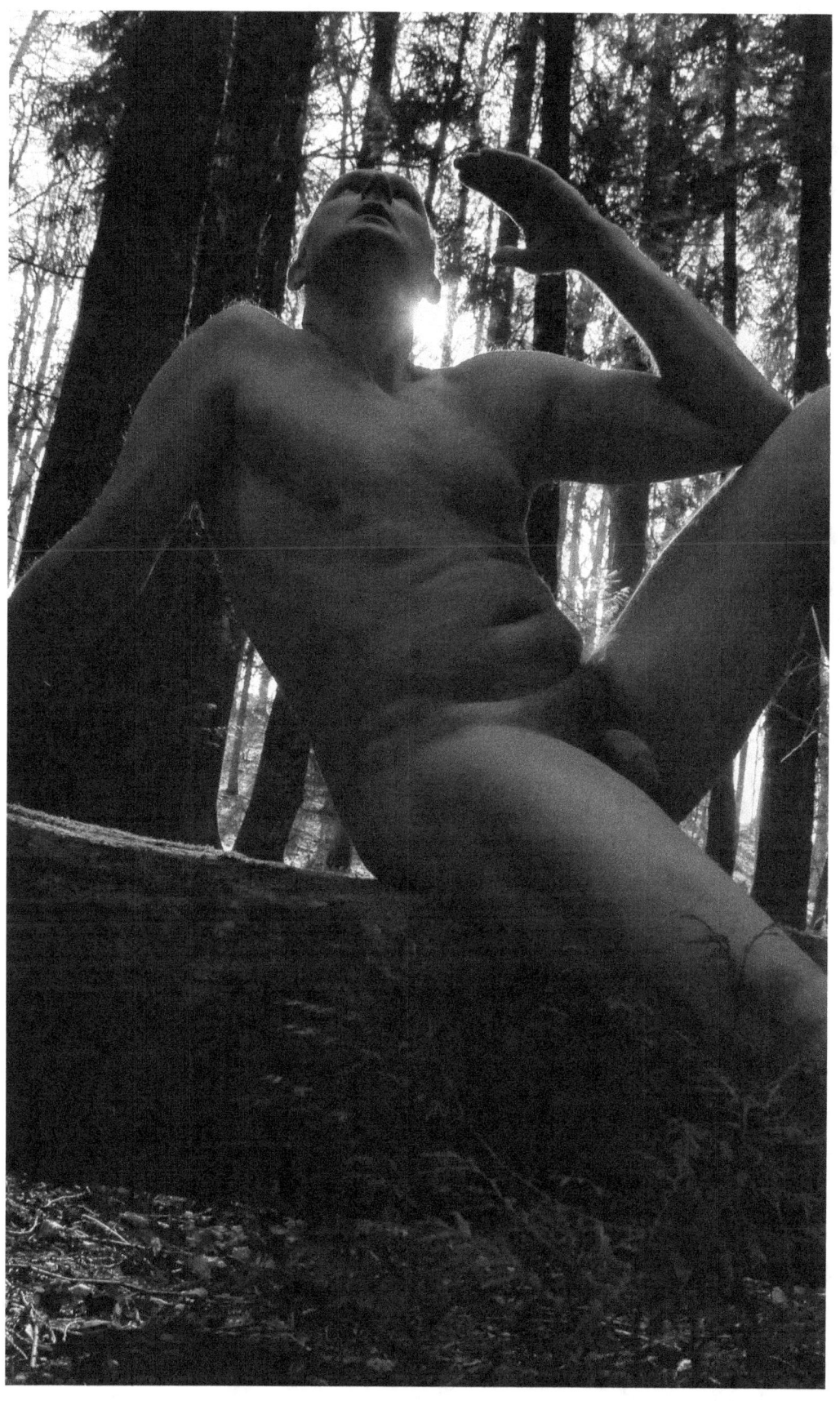

Water Where Life

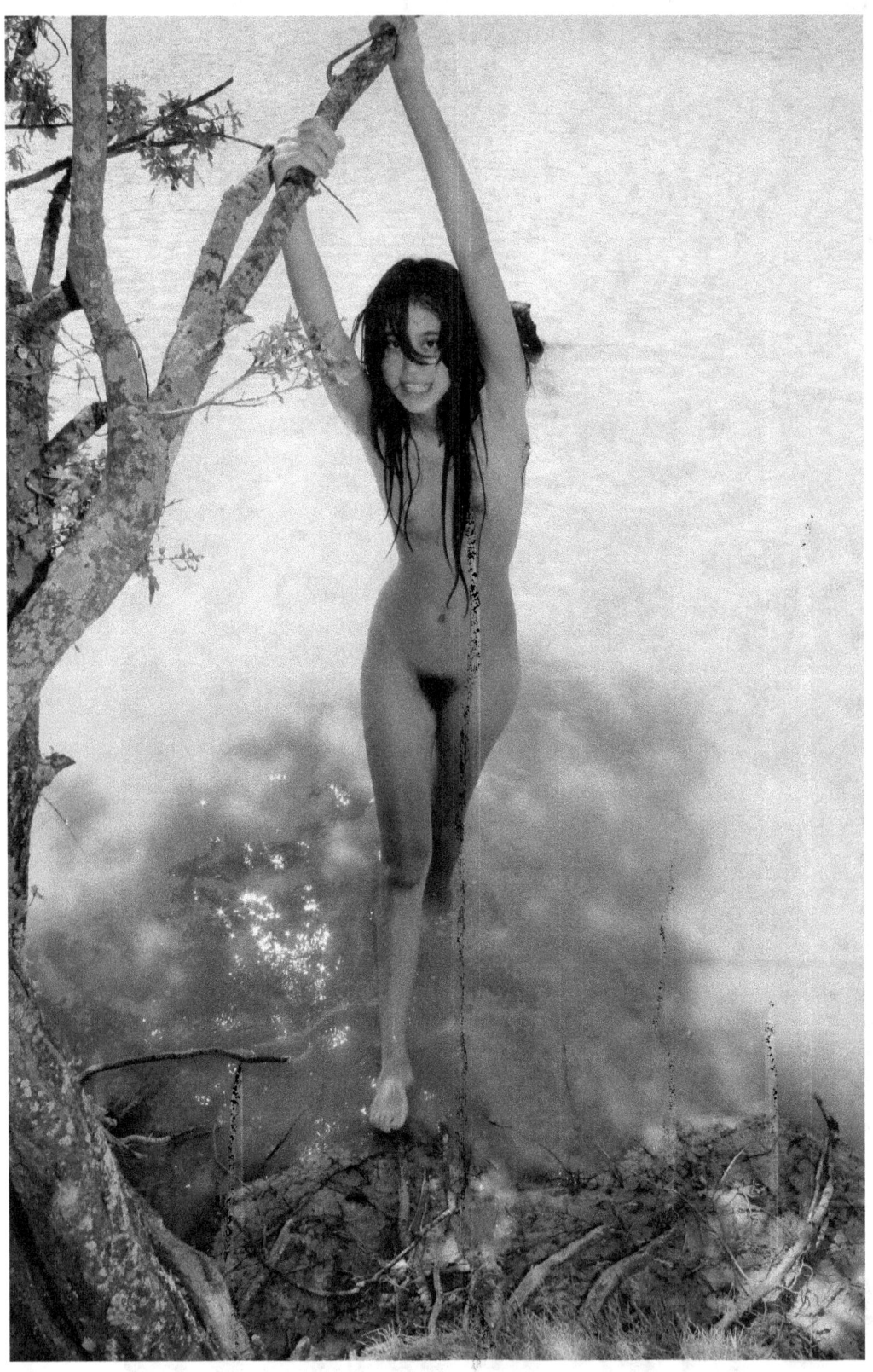

Progress, Form, Existence

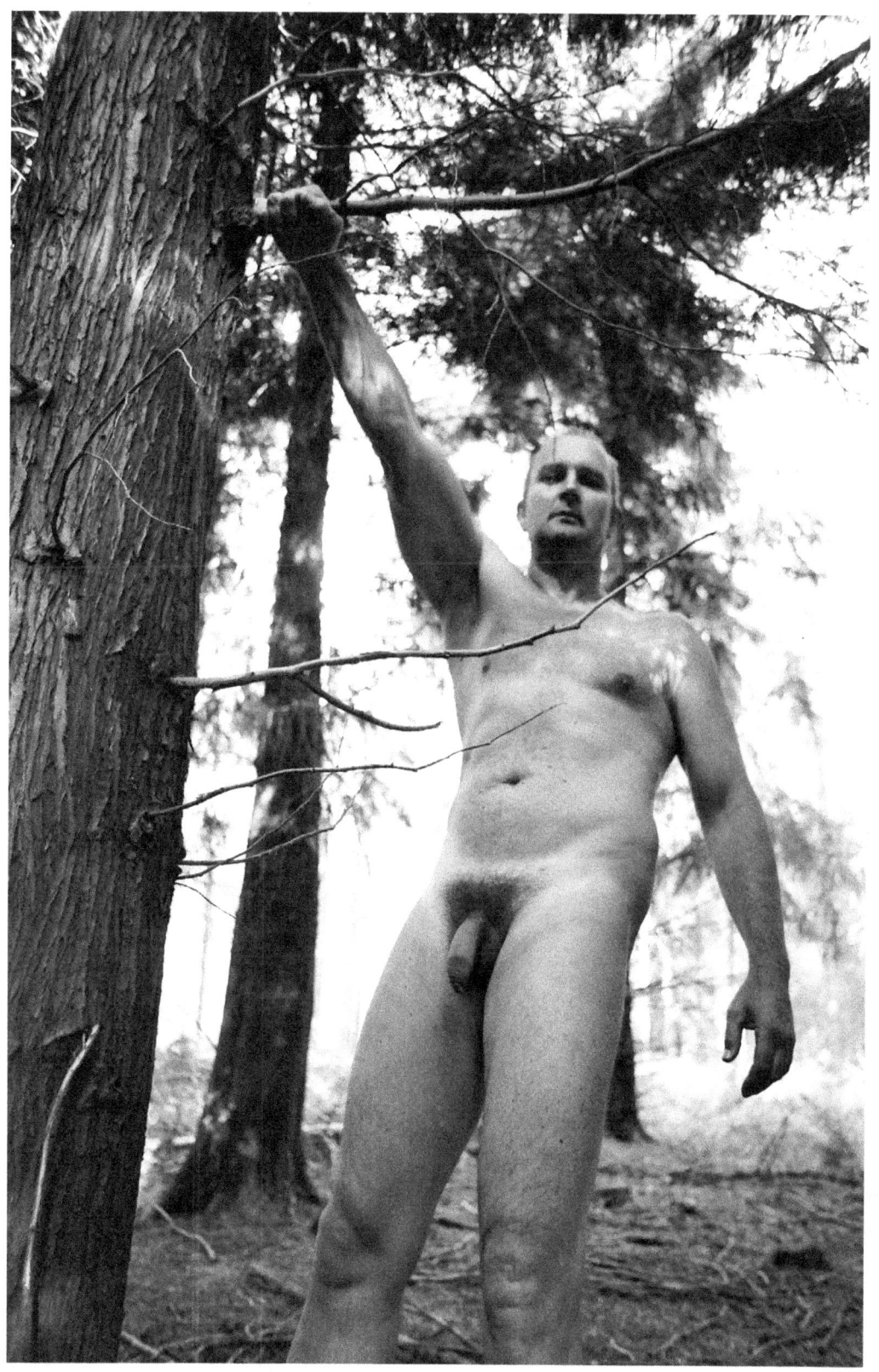

Xylem

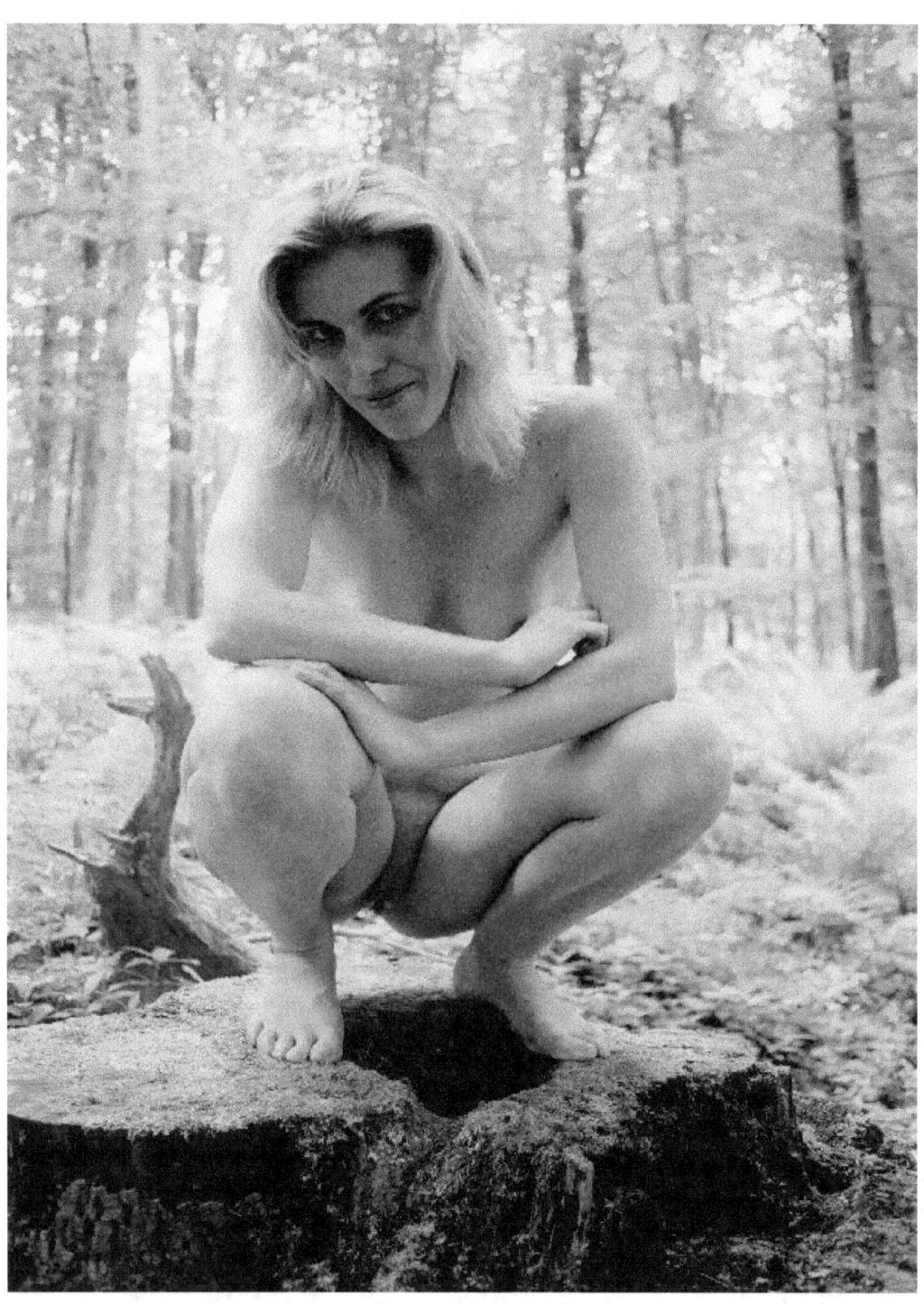

Esse is Percipi

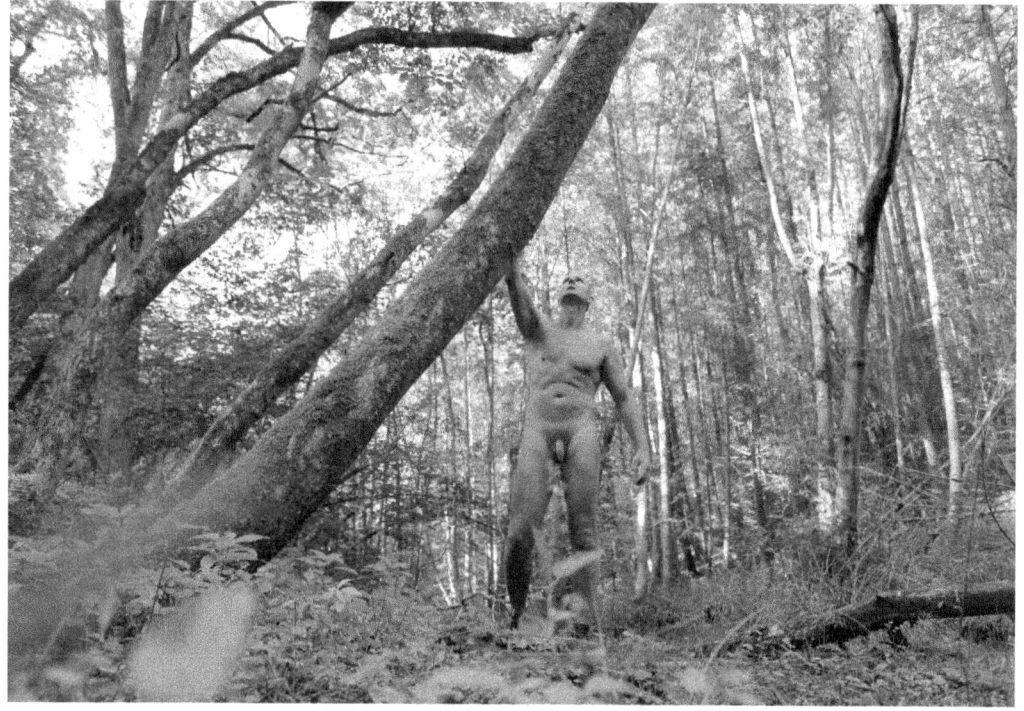

Will and Recurrence

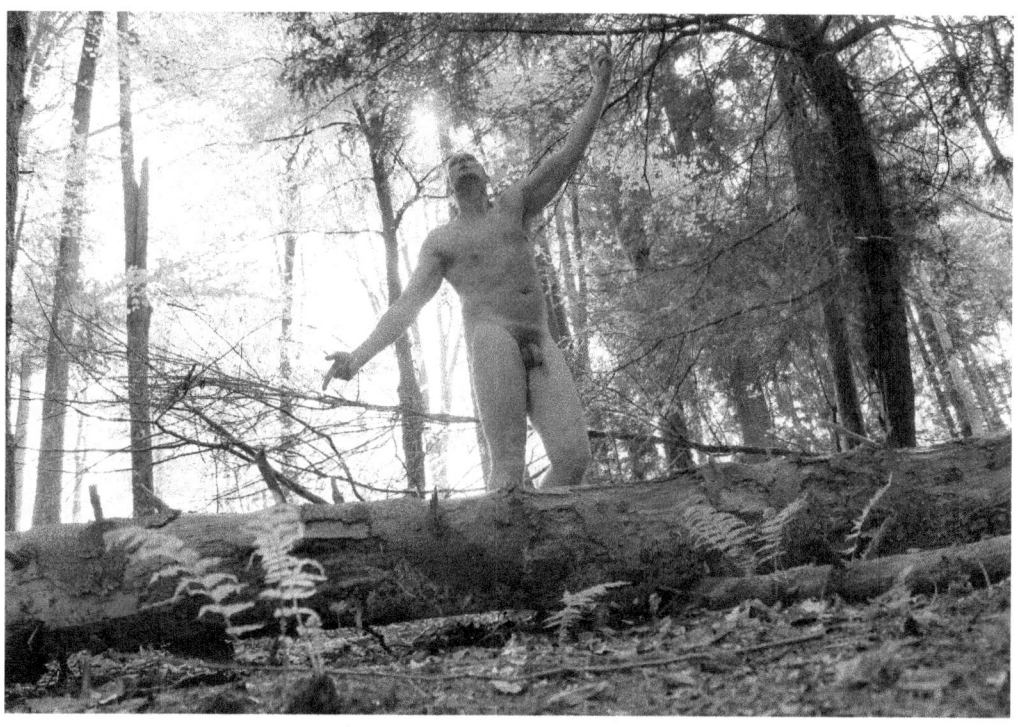

Geoform

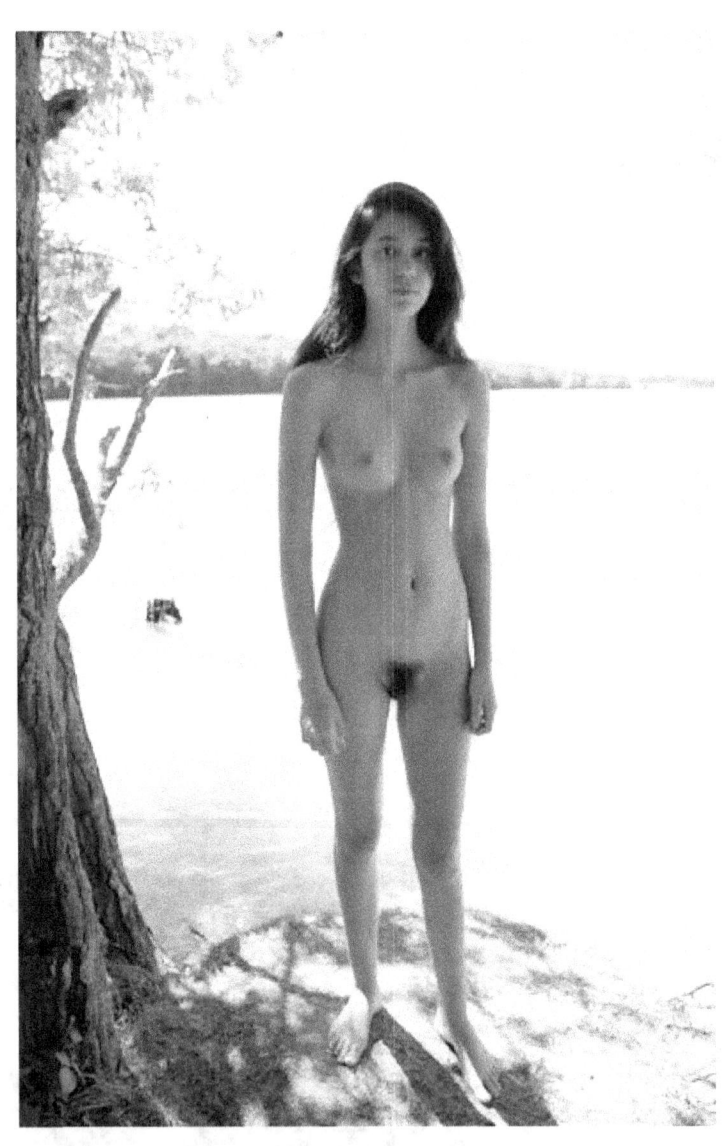

Amalgamation

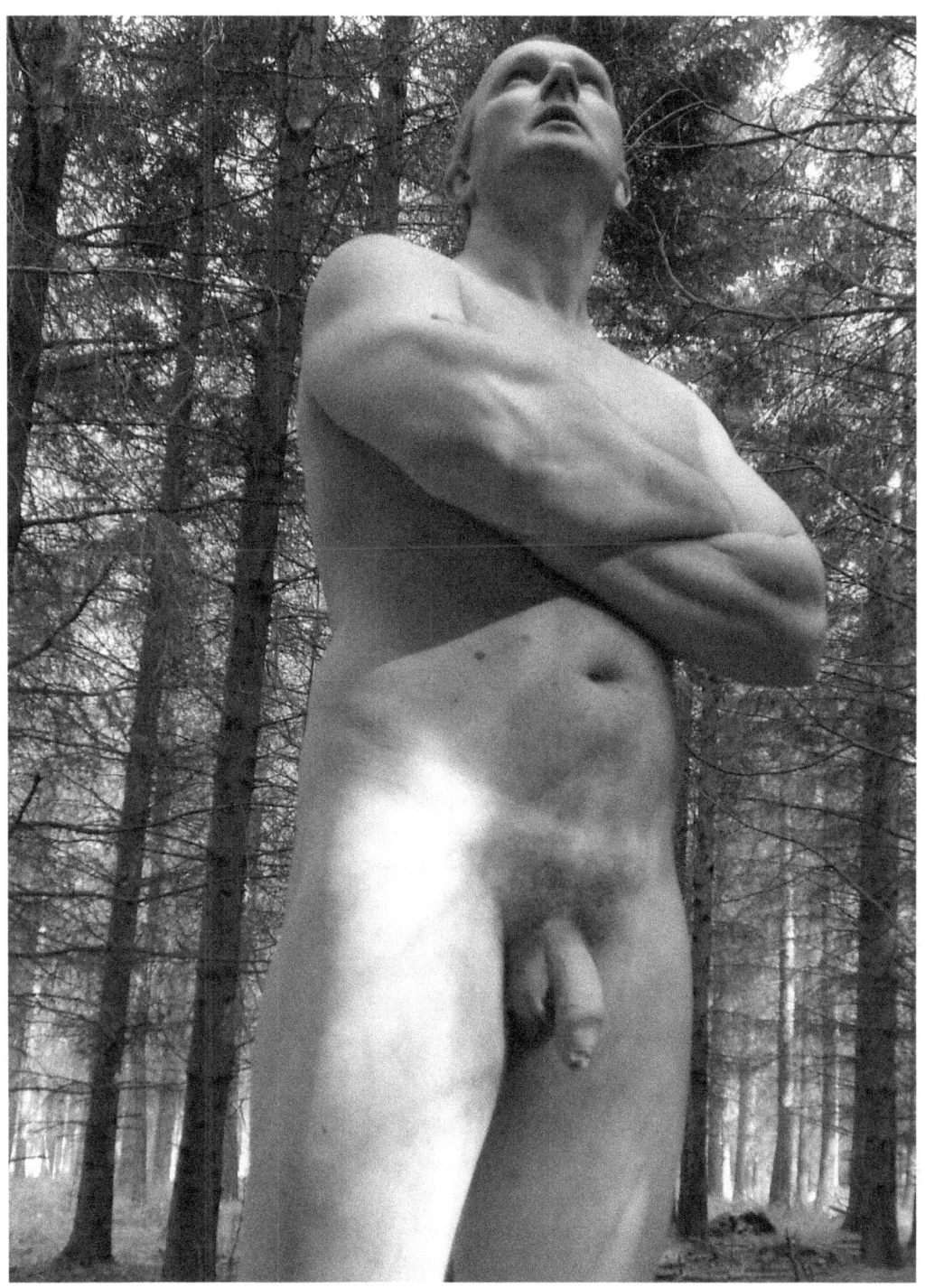

Gravitation

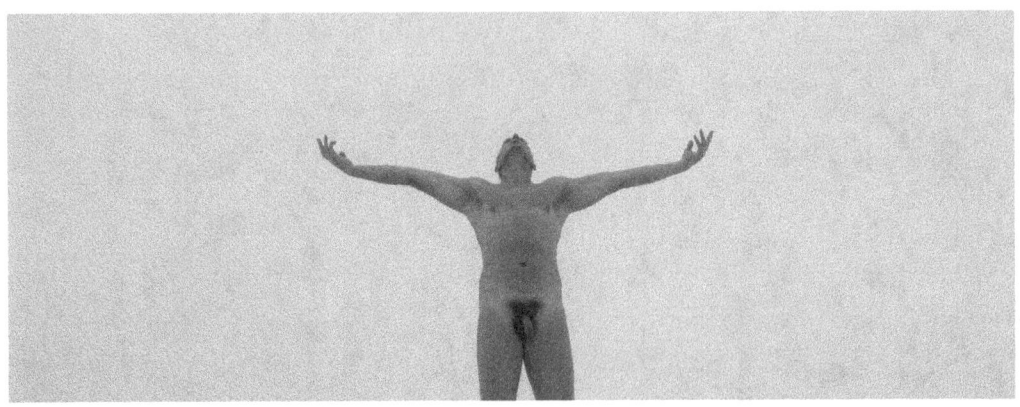

Lumen Accipe

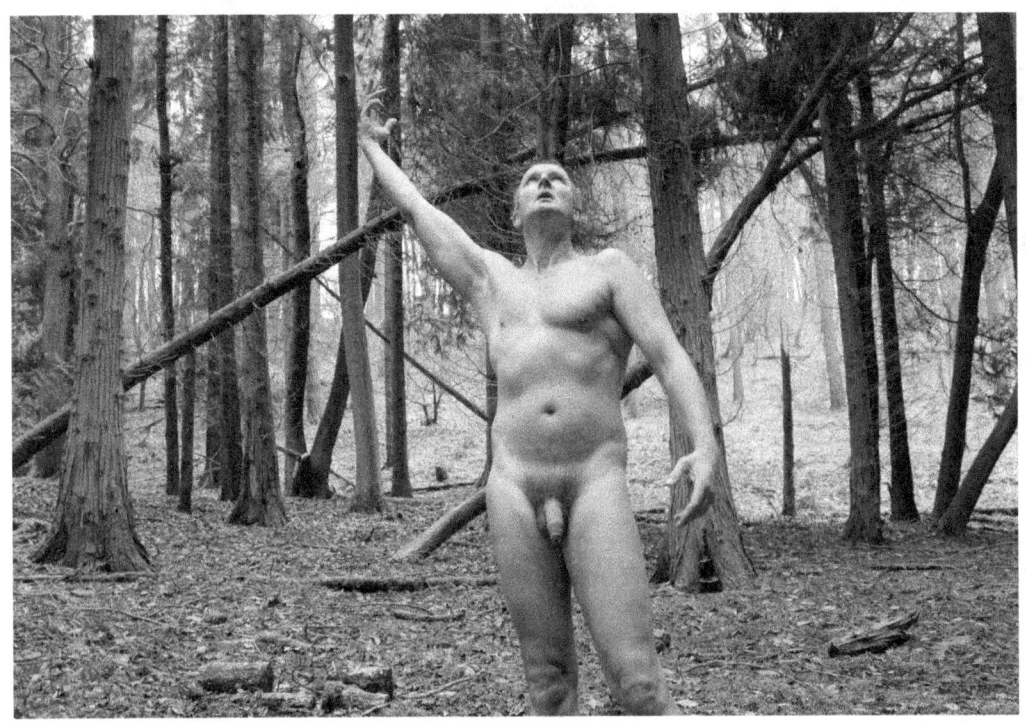

Found

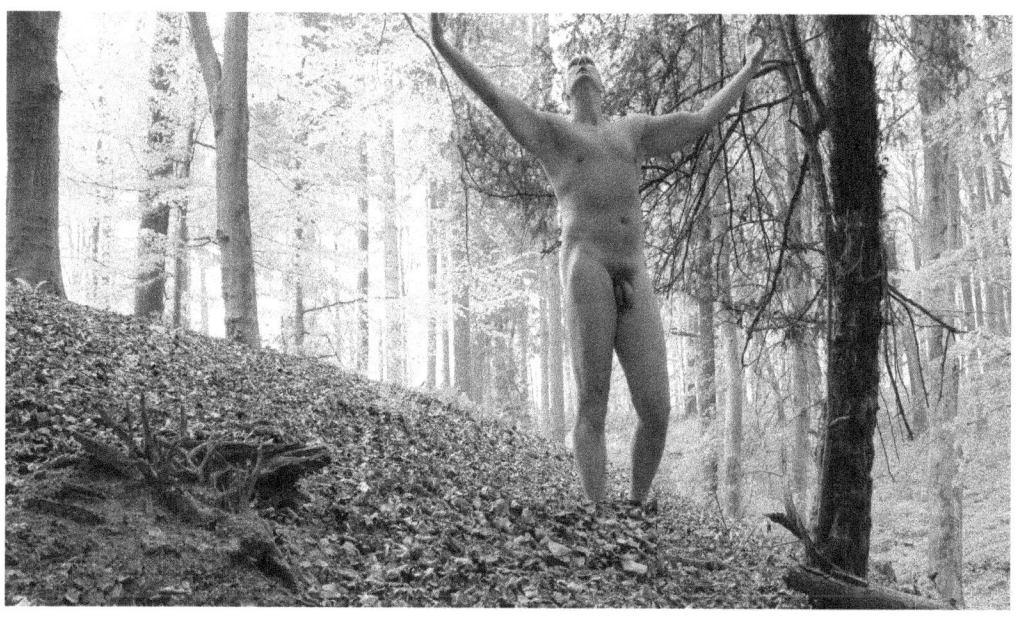

Lost

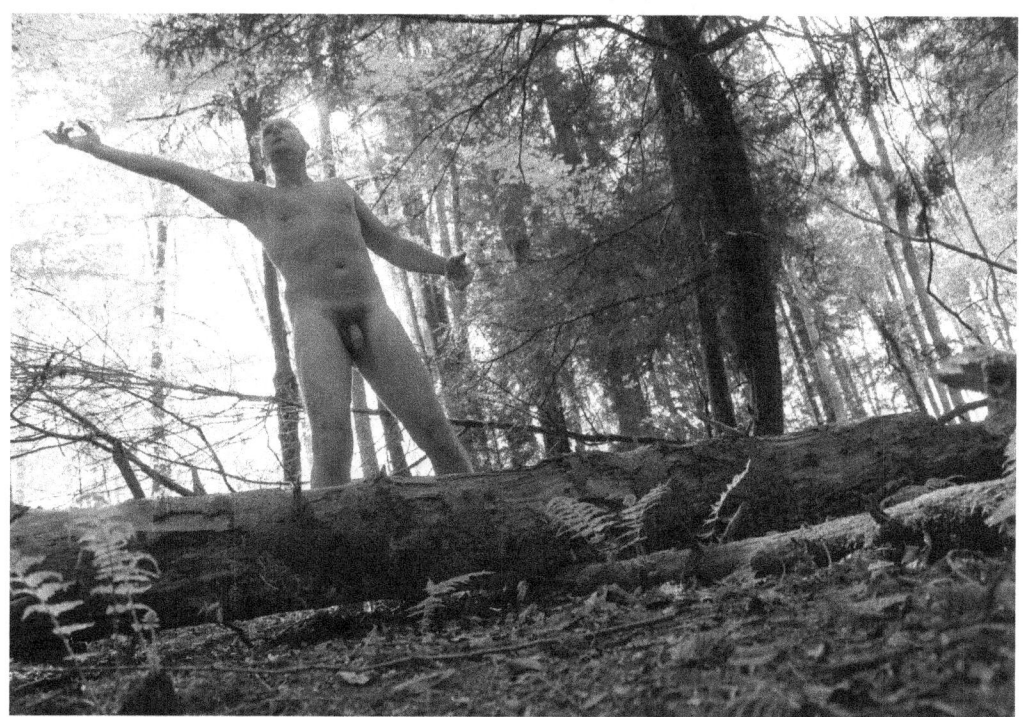

Was; A Covenant

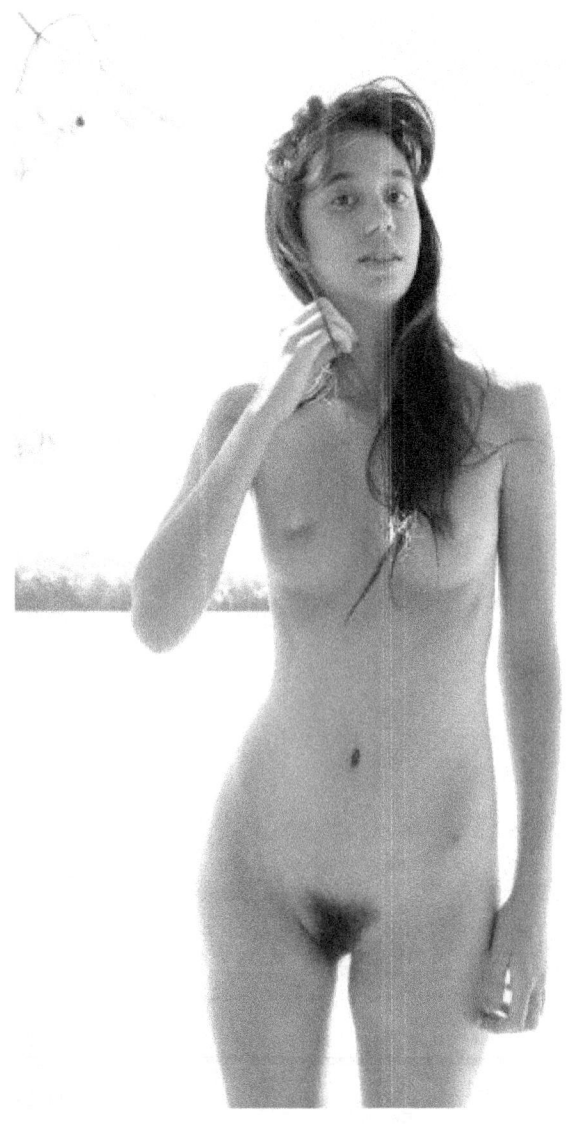

Transmigration of Elements

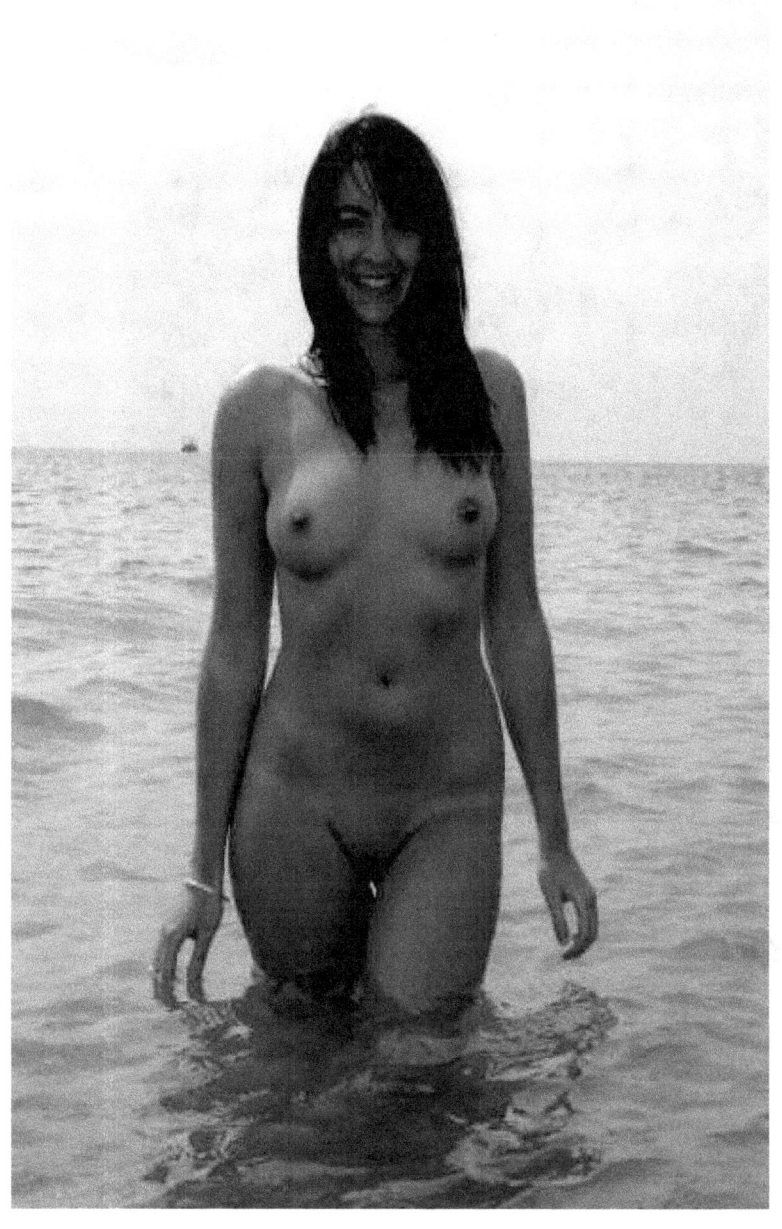

Clavigera

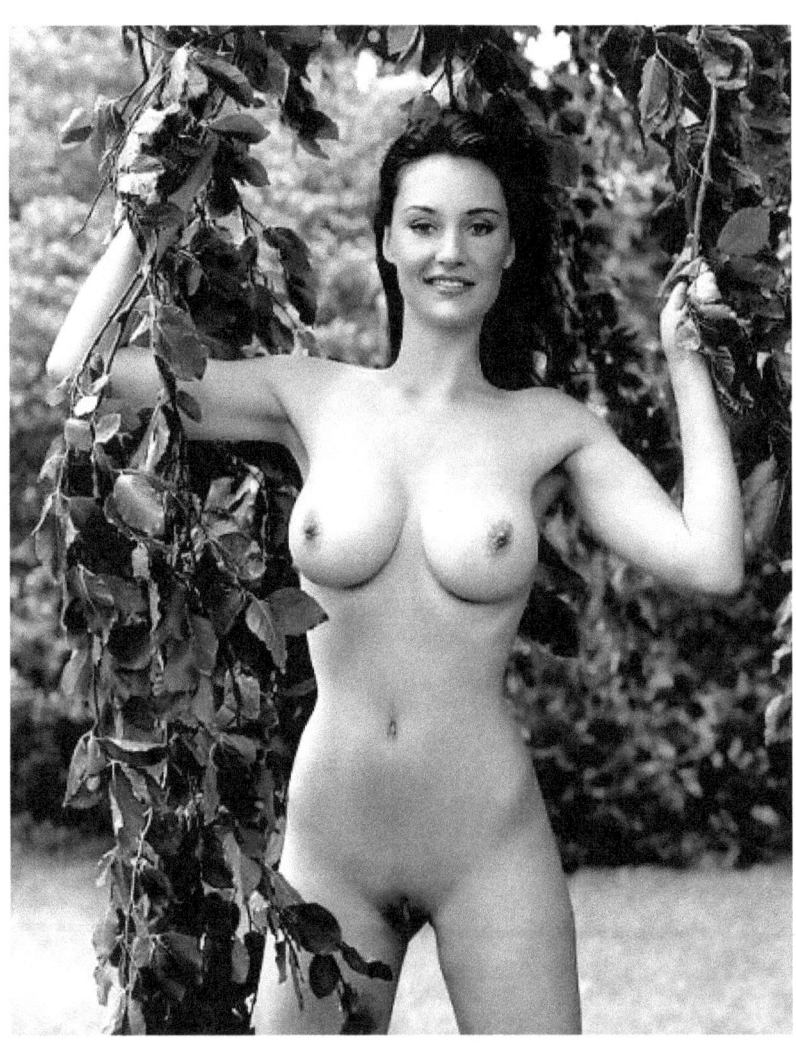

The Synapse State

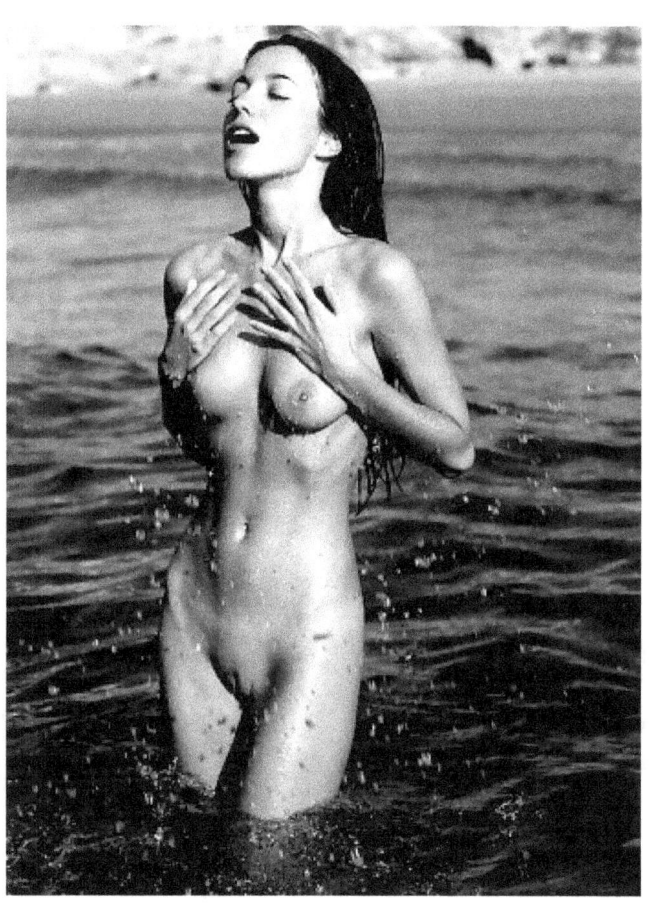

The Elements Have Changed

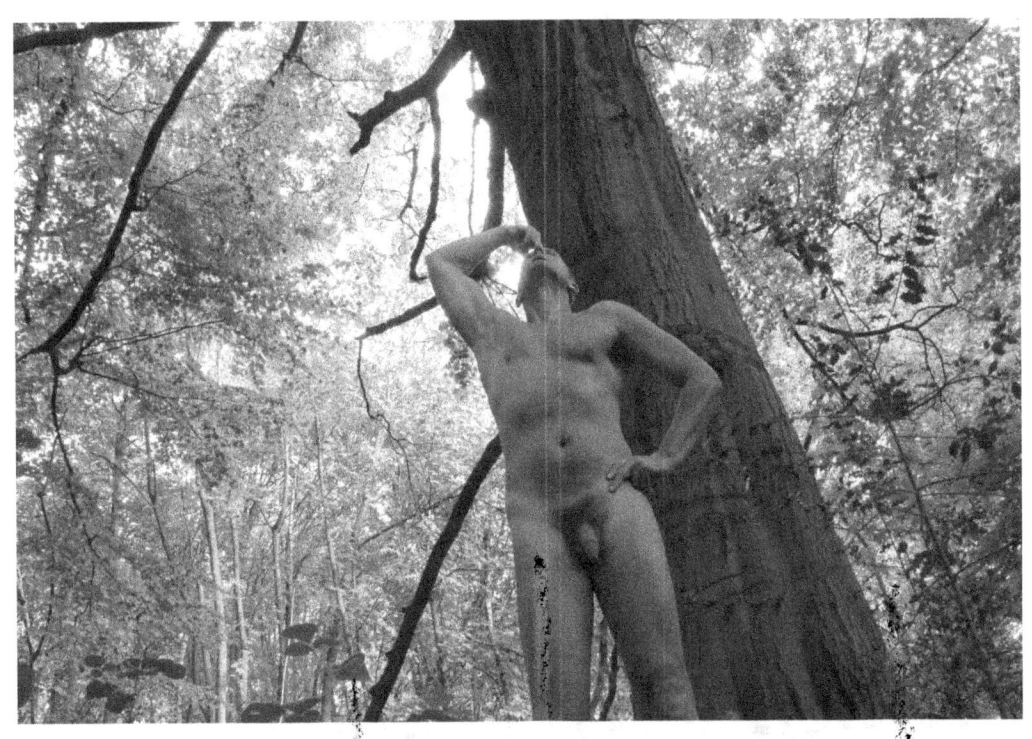

From Thence, The Earth Responded

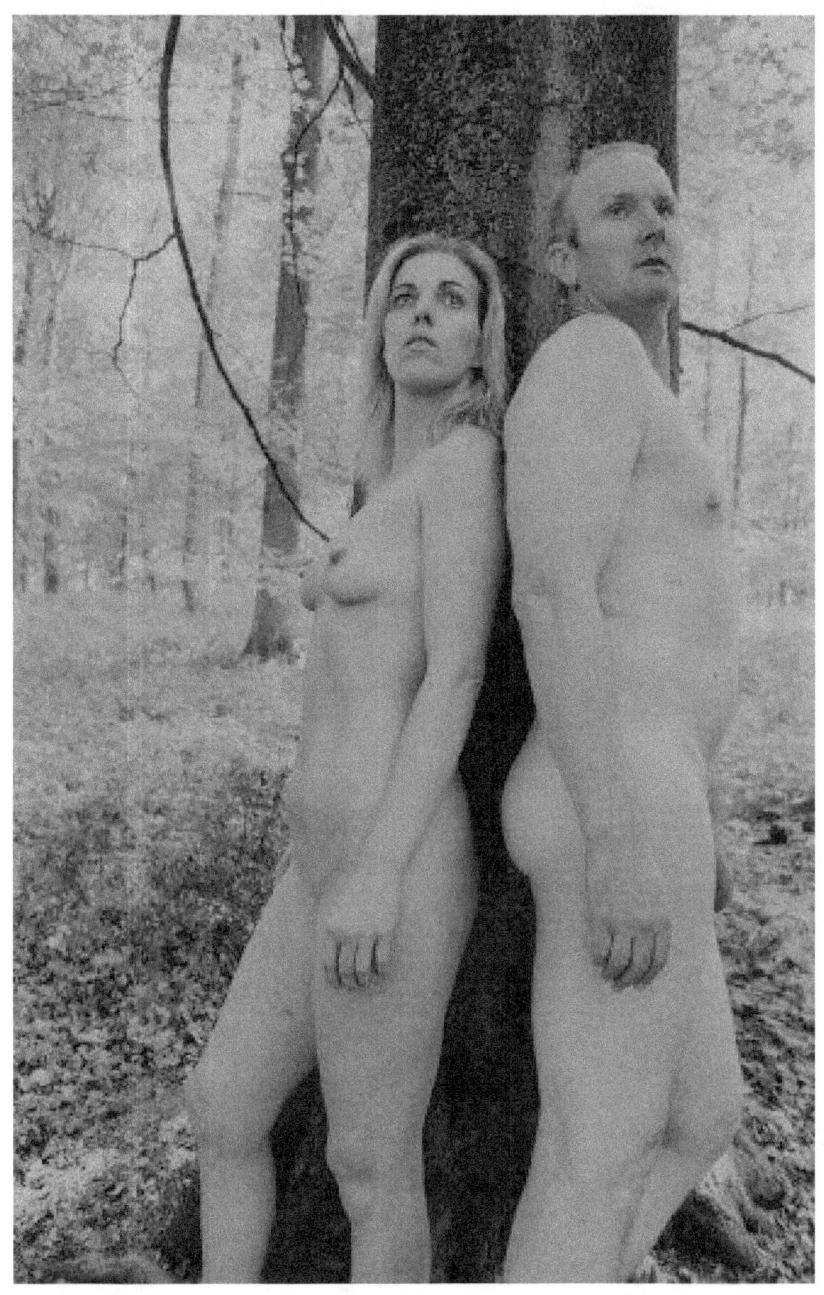

The Inevitability of Carbonism

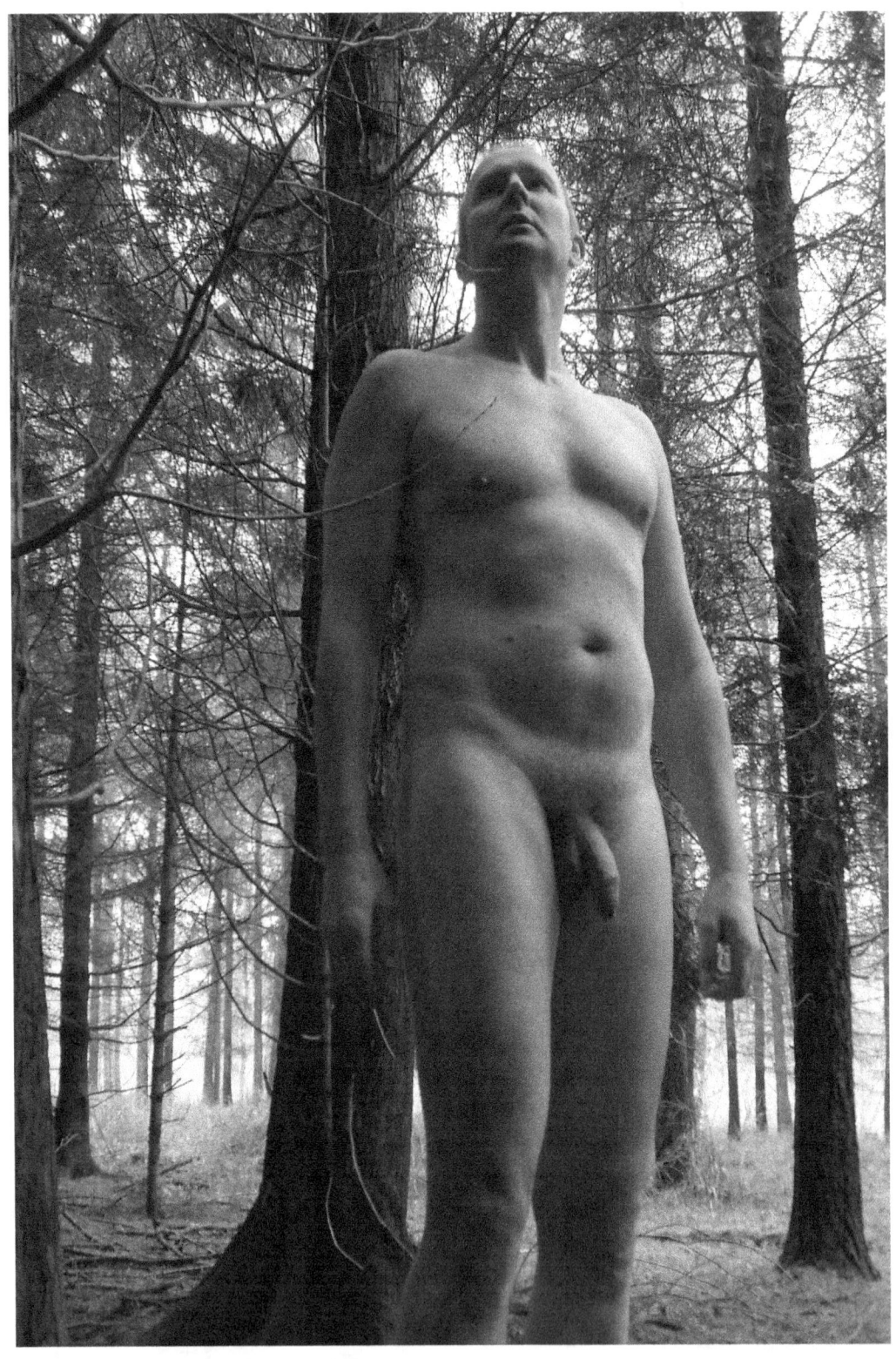

A Treatise Was Established

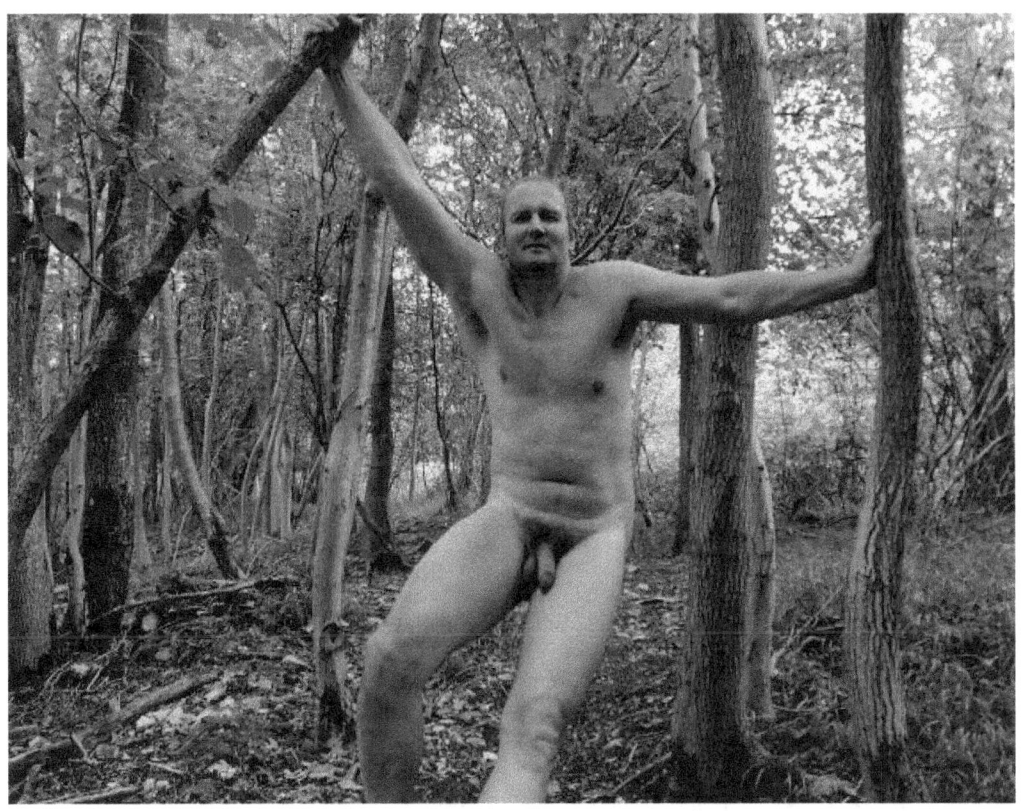

Now One

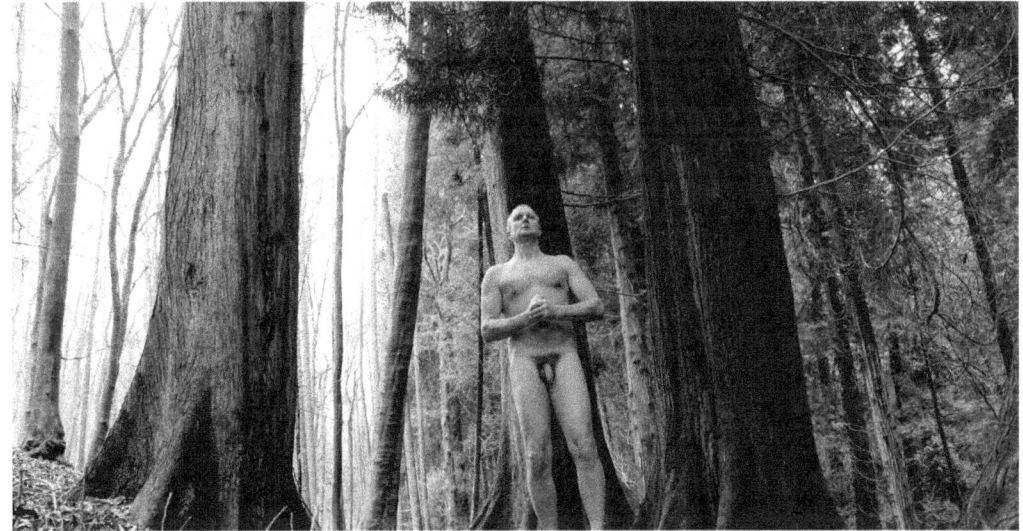

Tragedio

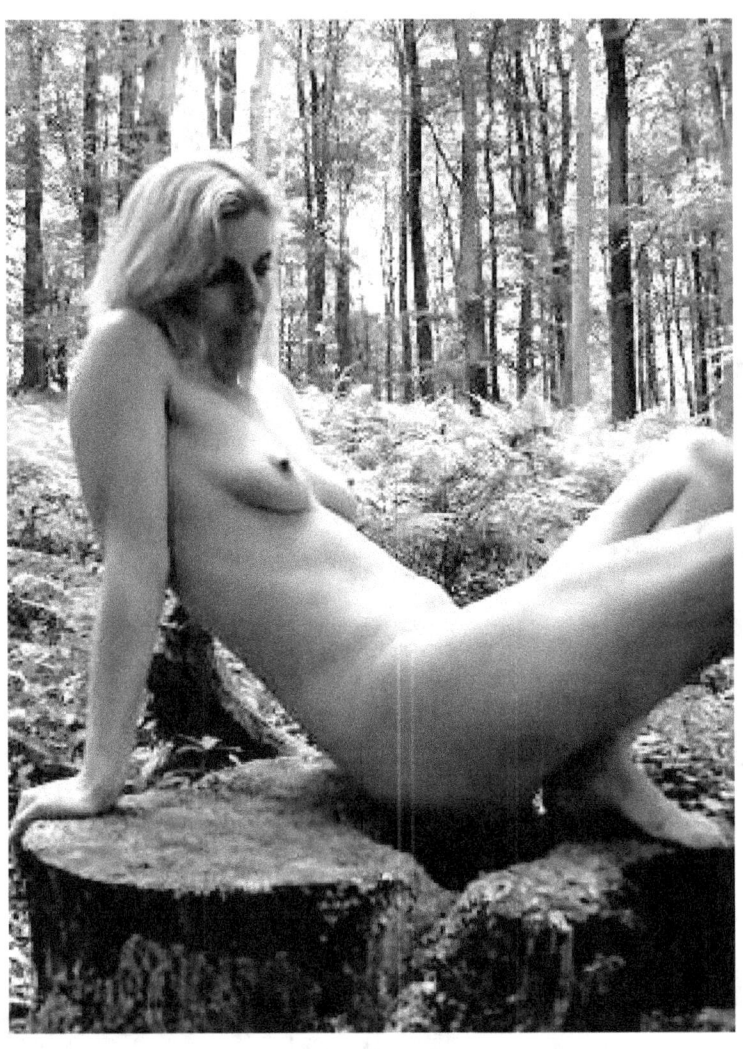

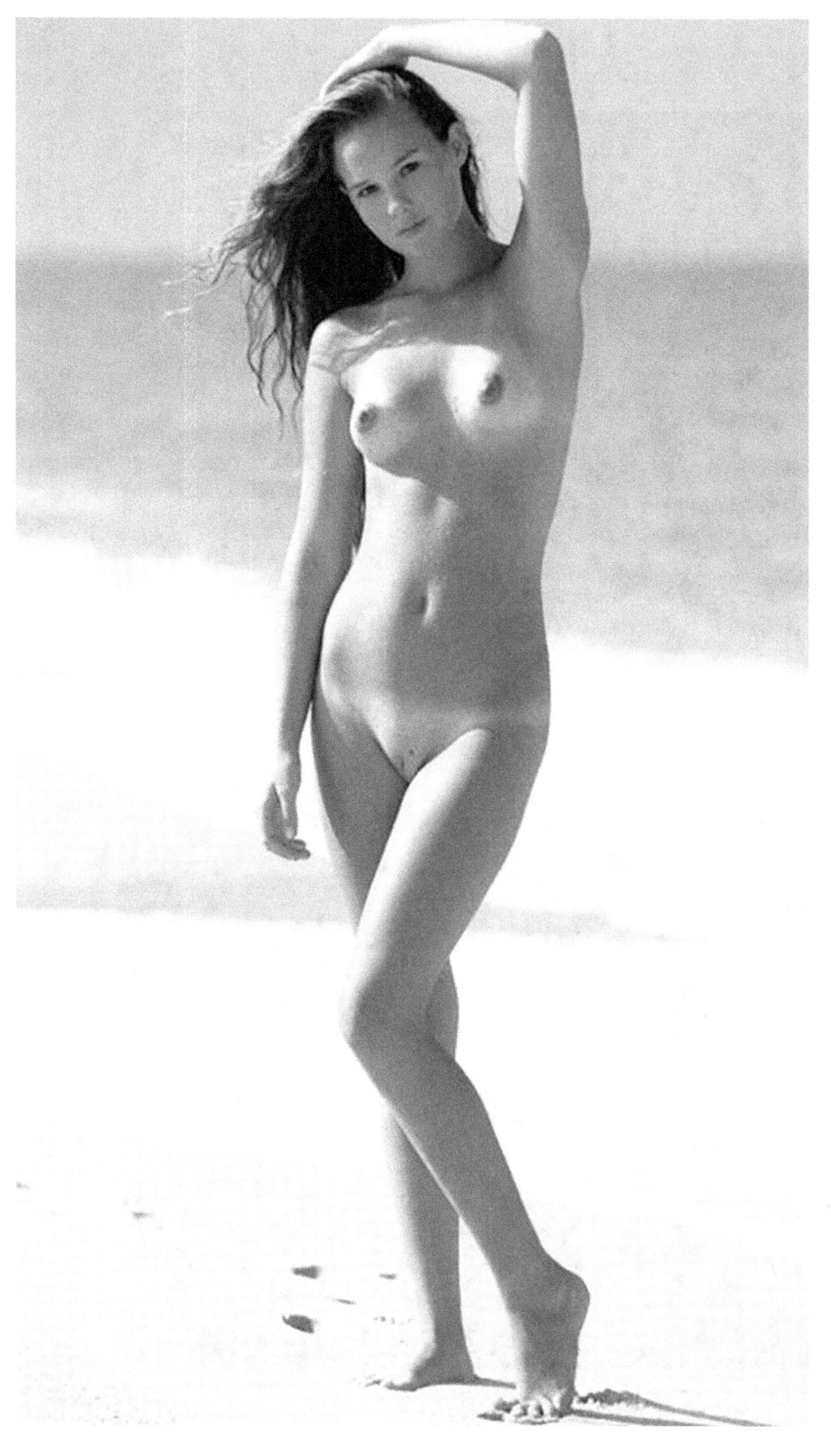

Life as One

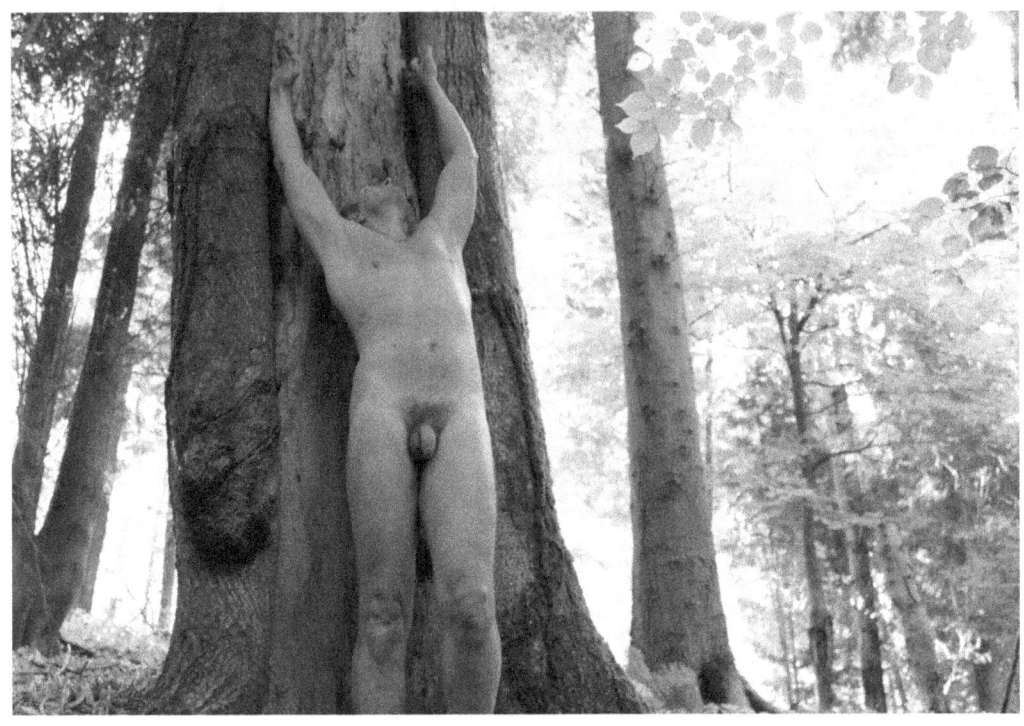

A Change Afoot

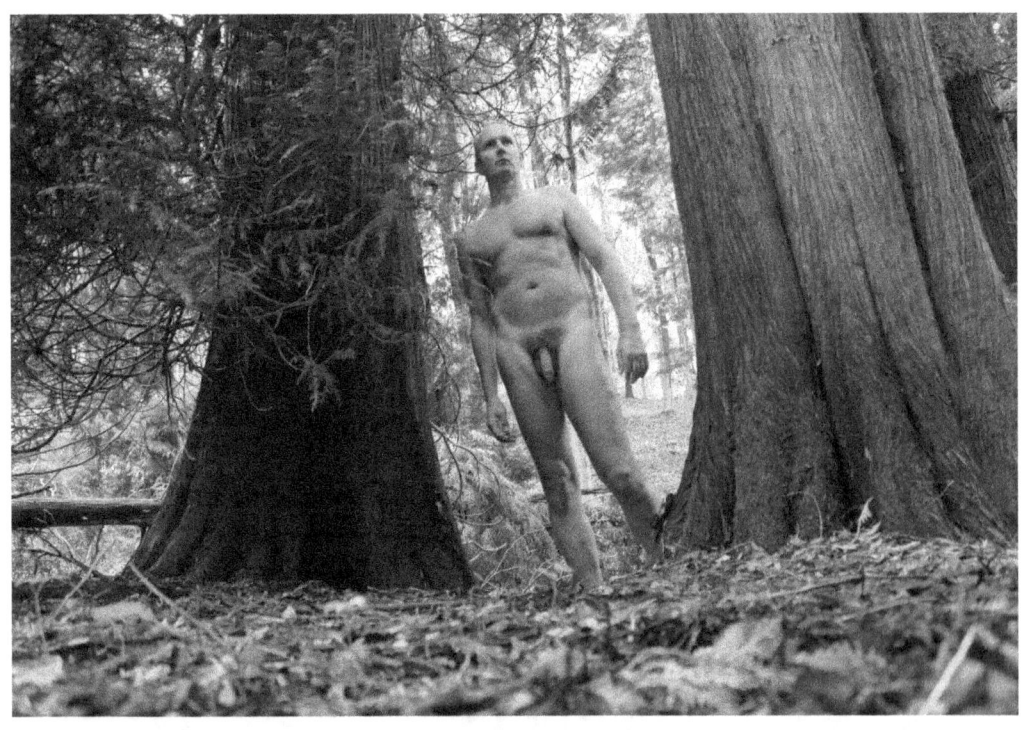

Emergence Is Our Witness

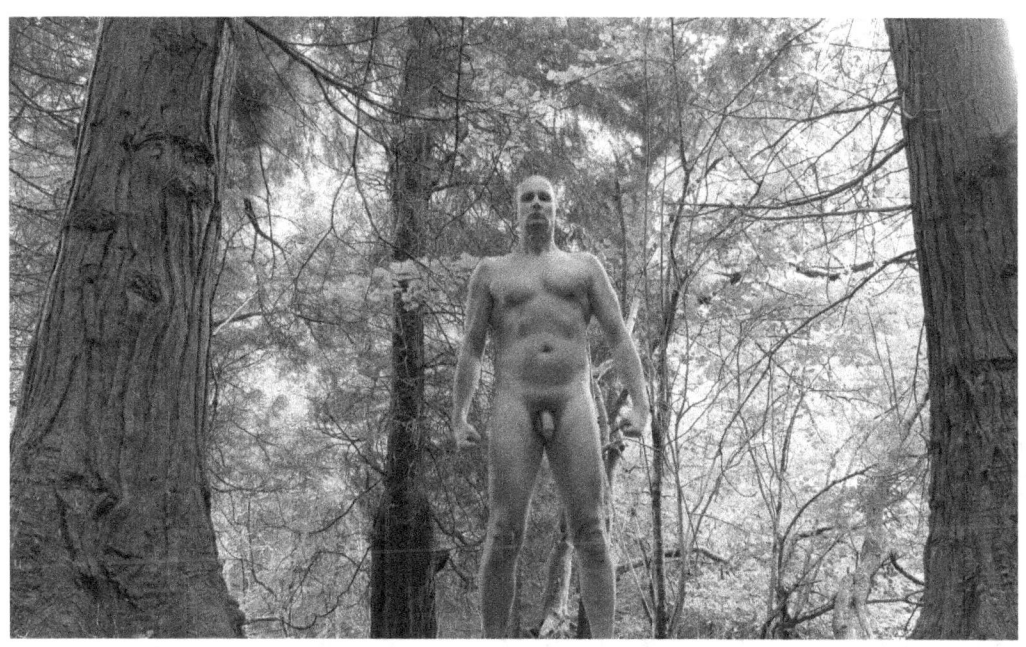

The Green Man

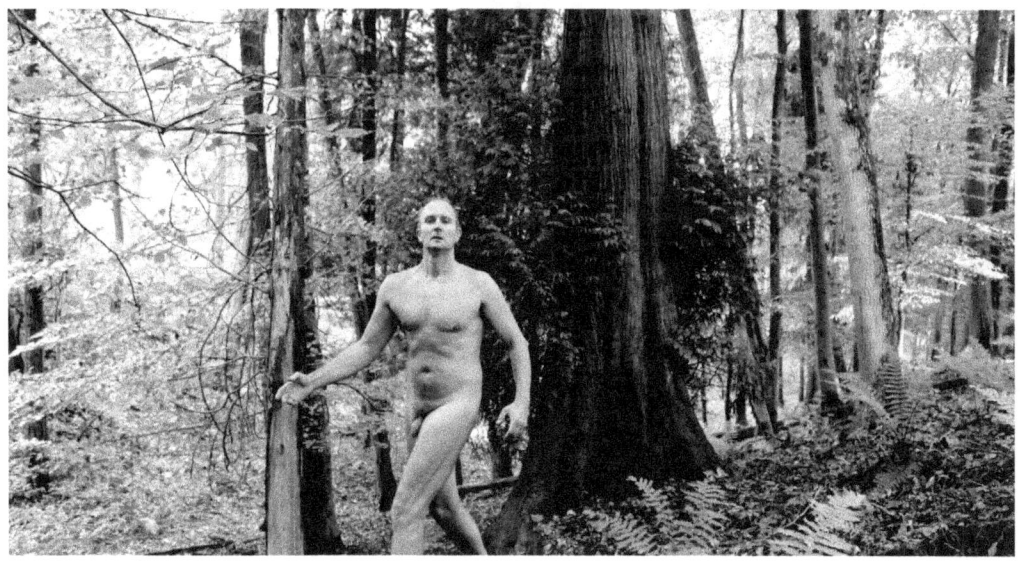

Triumvir

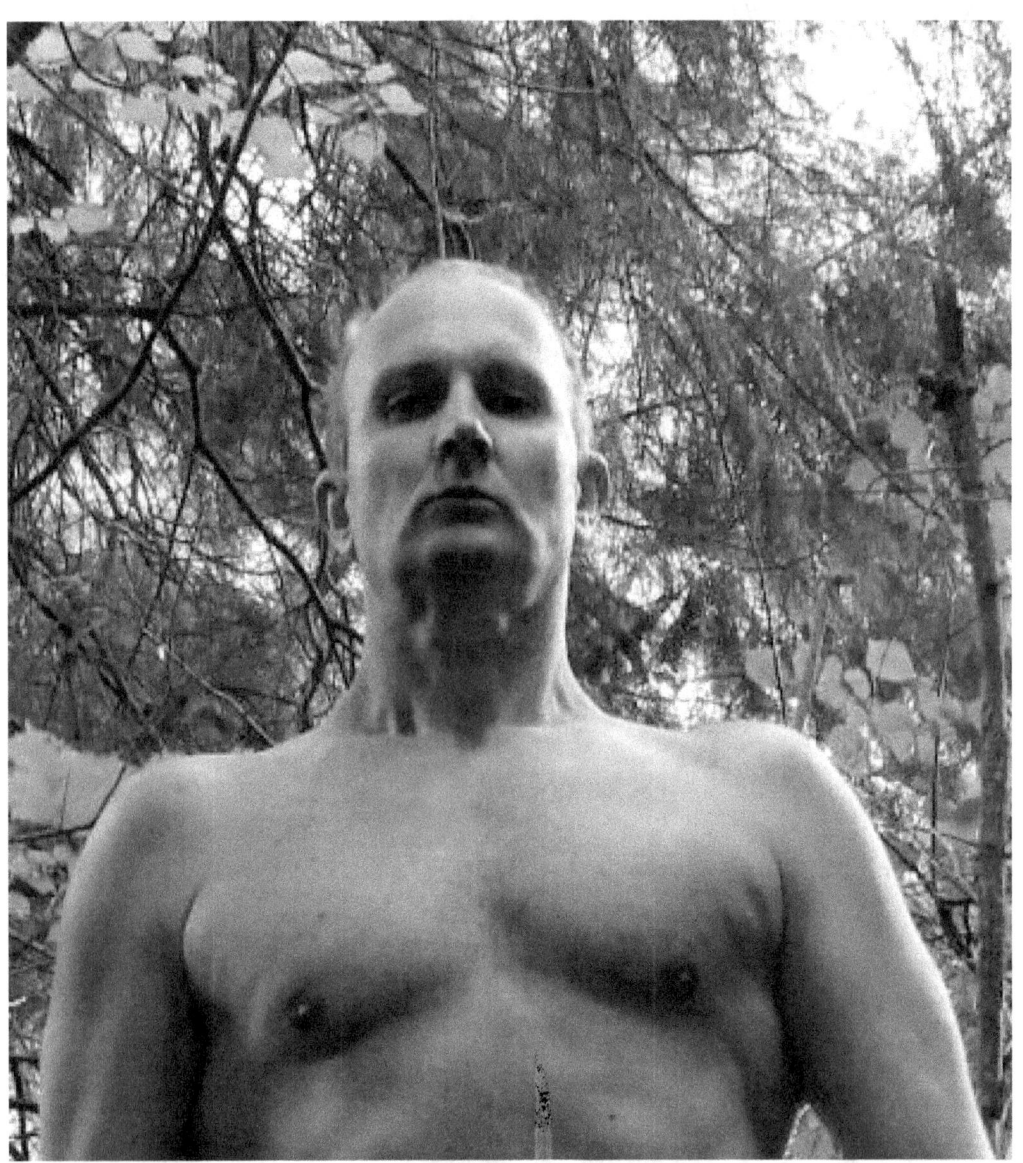

Re-Creation

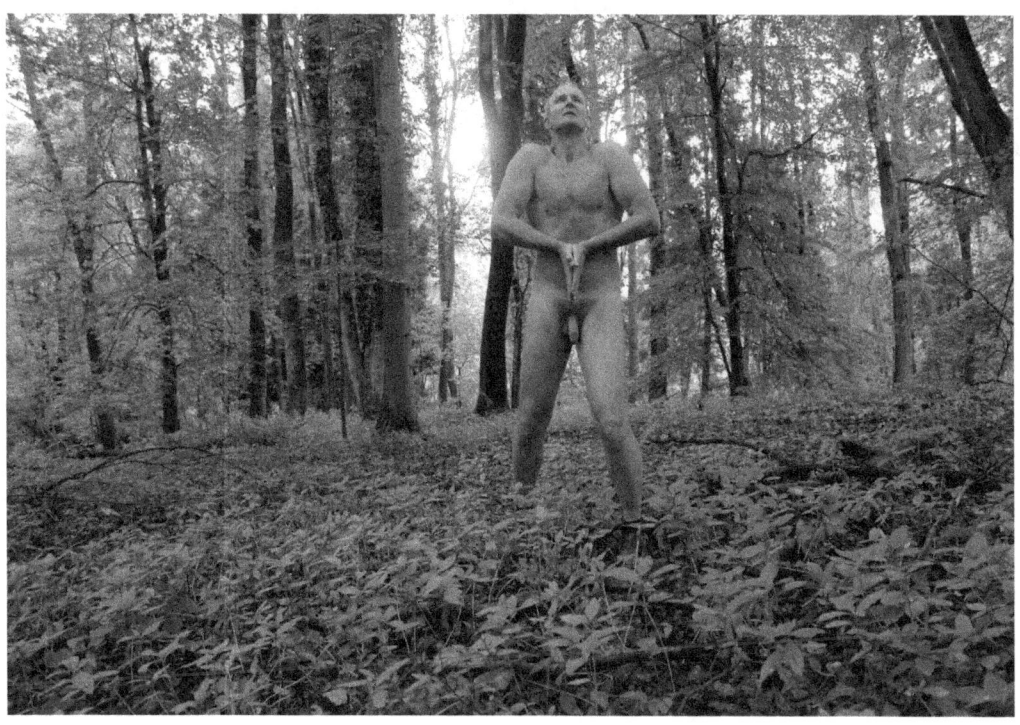

Impasse

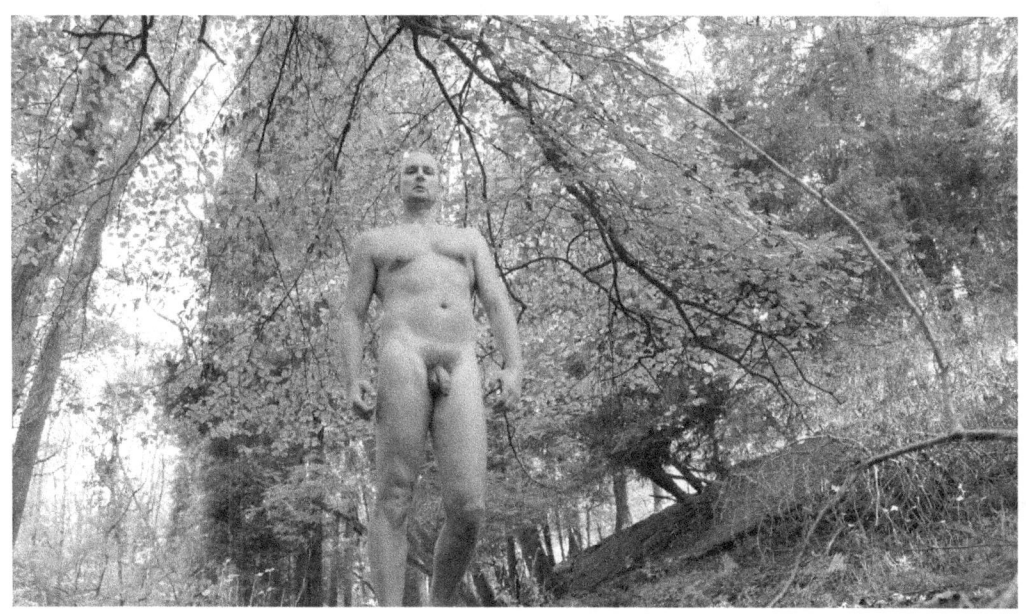

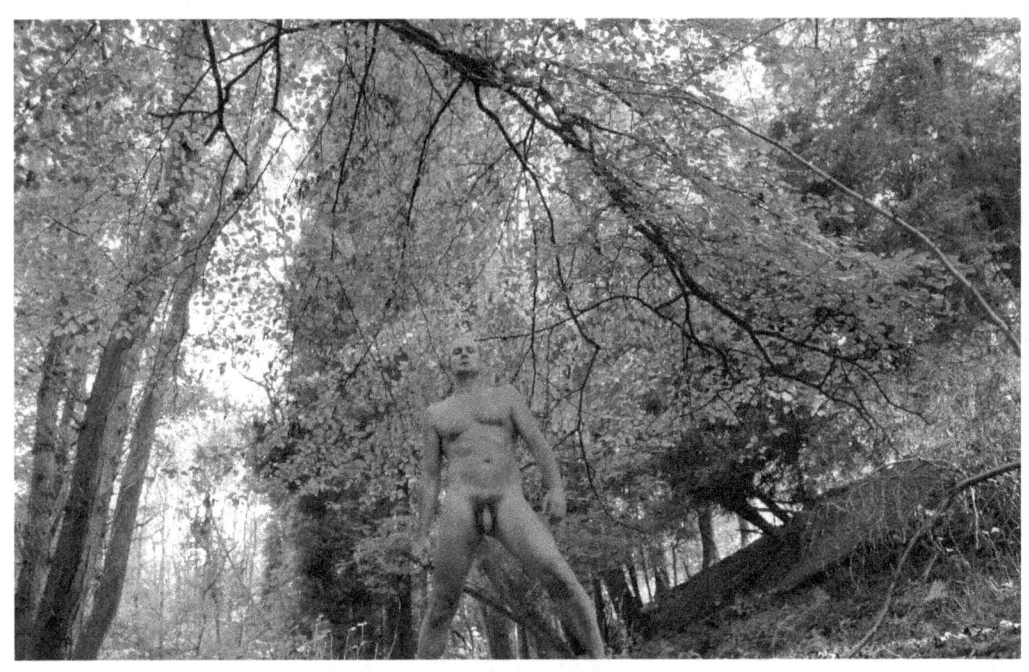

Light

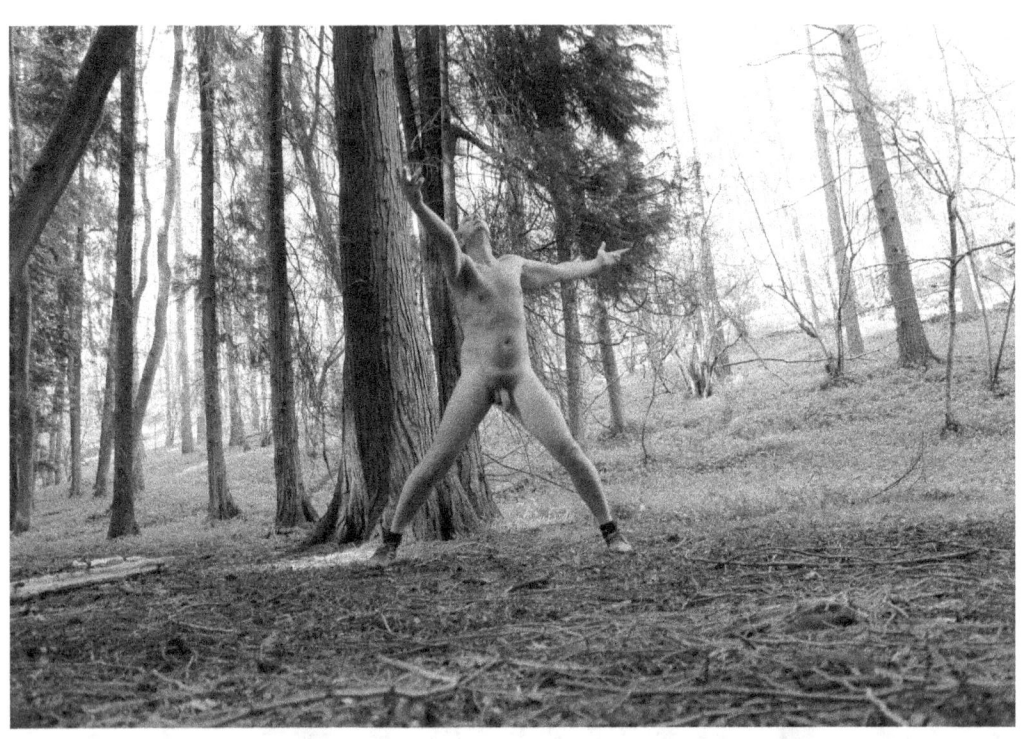

Conclave

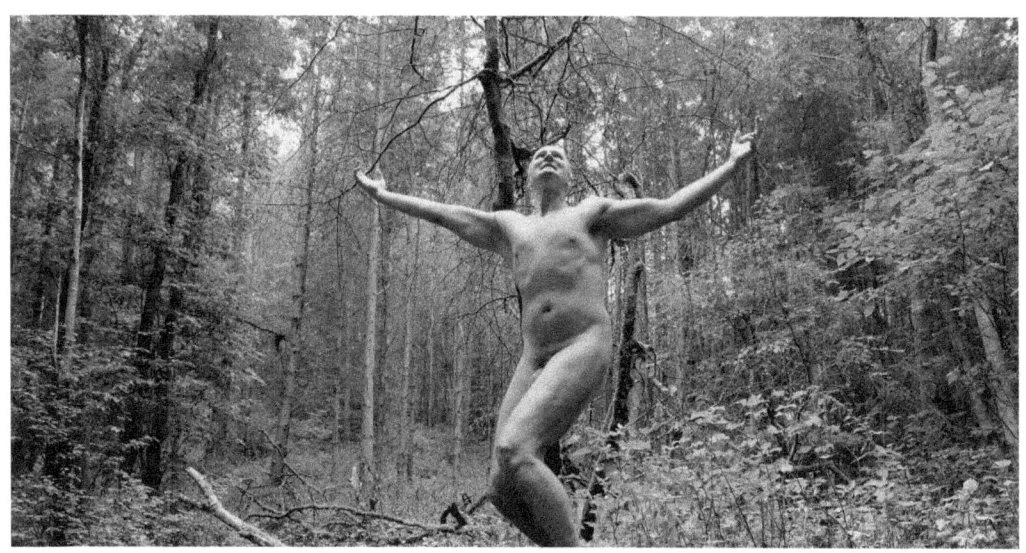

Level

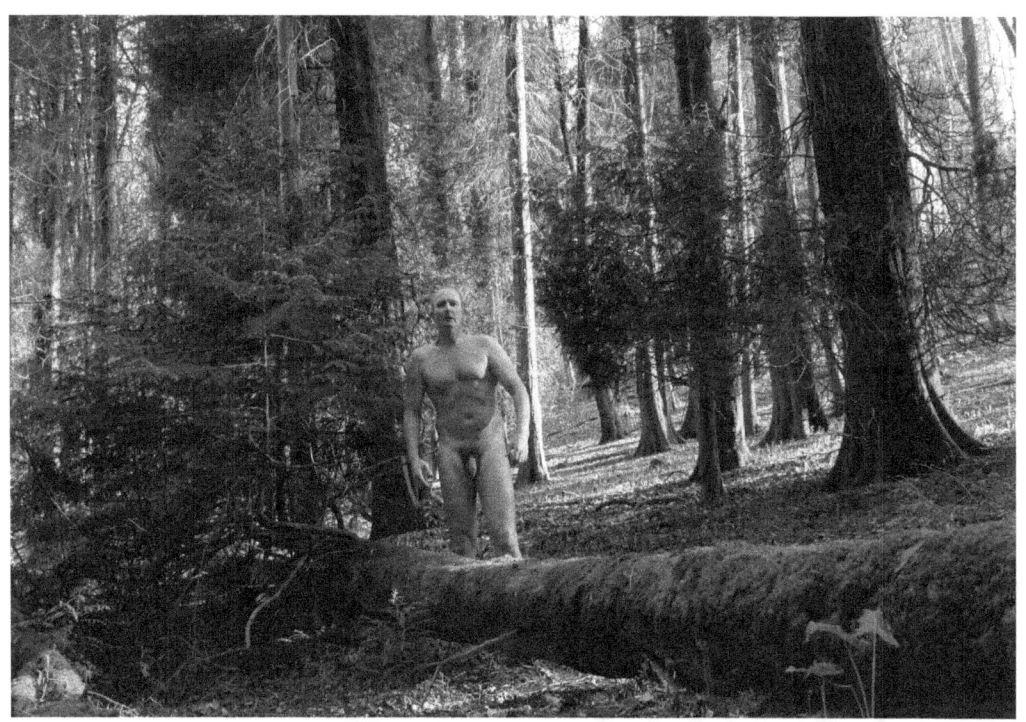

Constratum

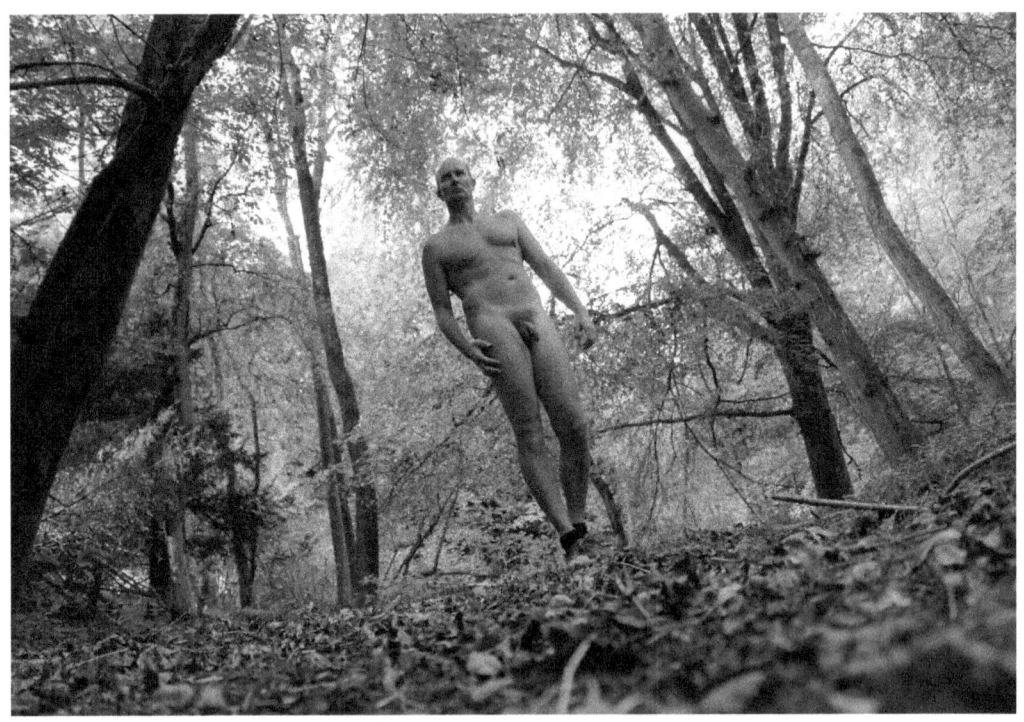

Expansion

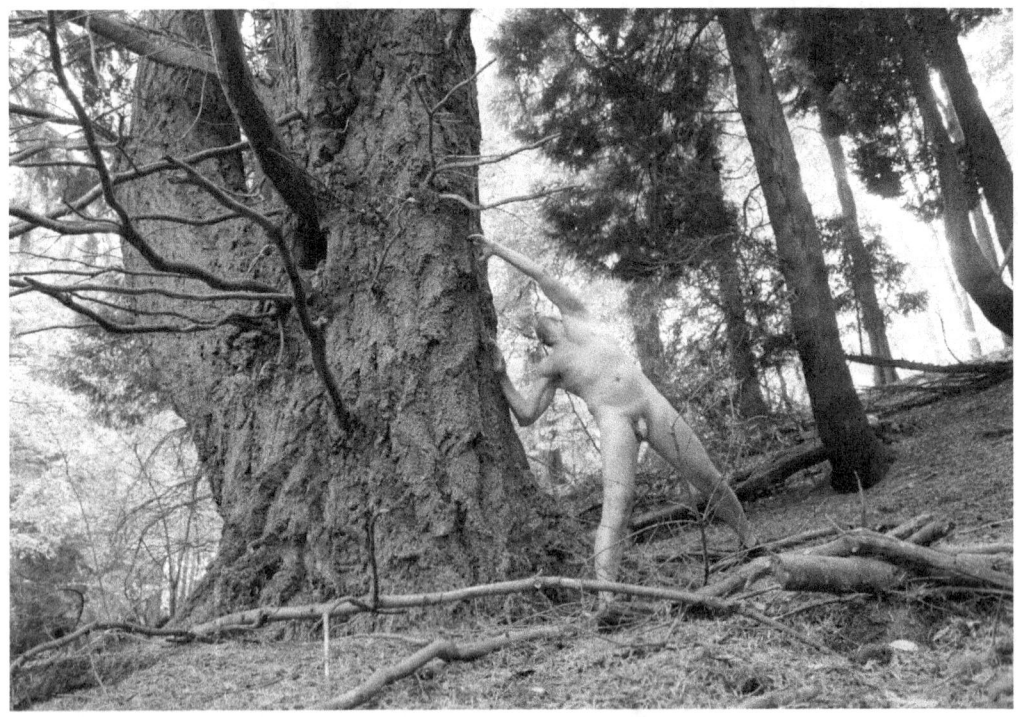

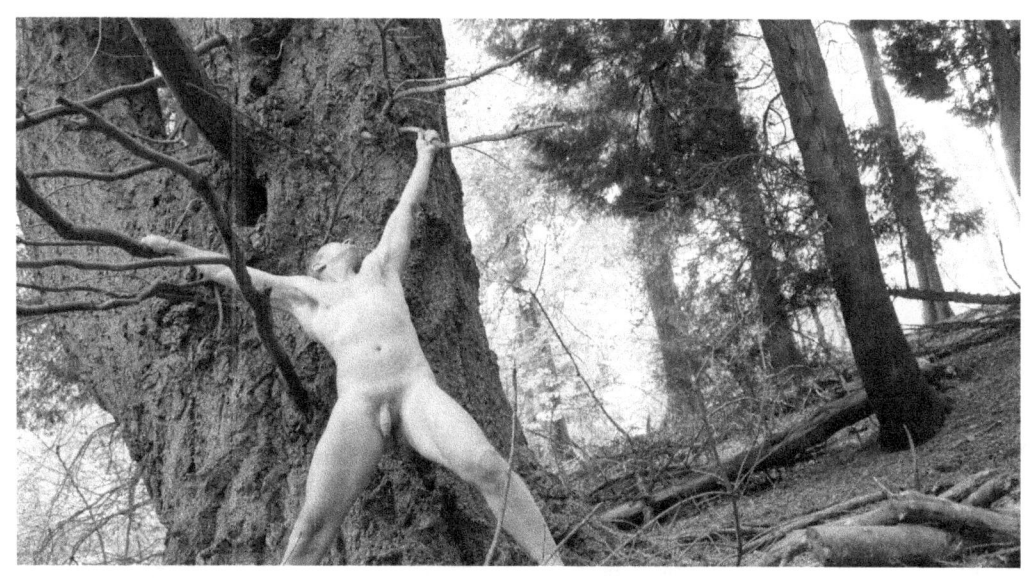

Now Thus

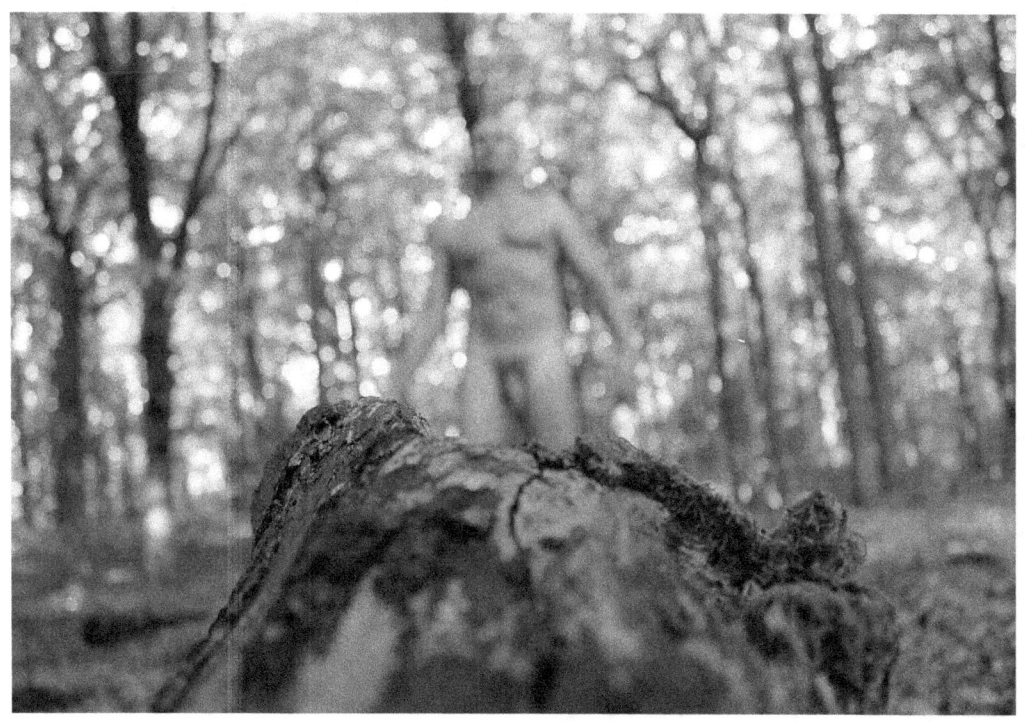

Perceptio

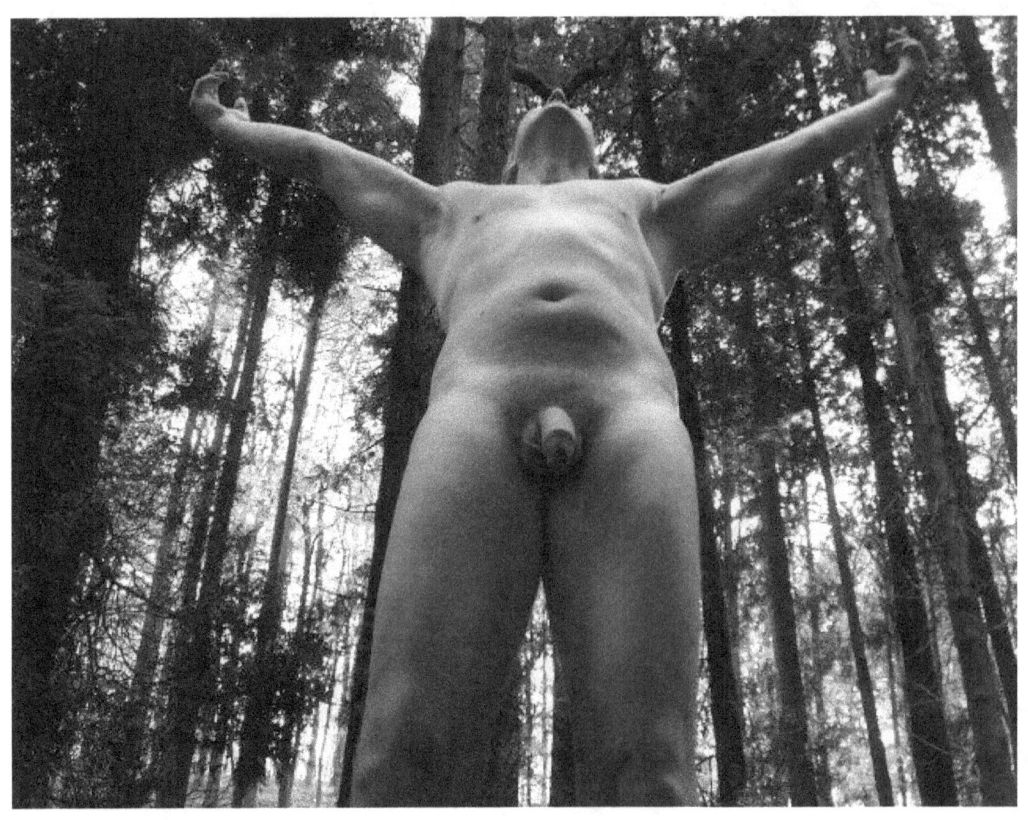

Lumen Accipe II

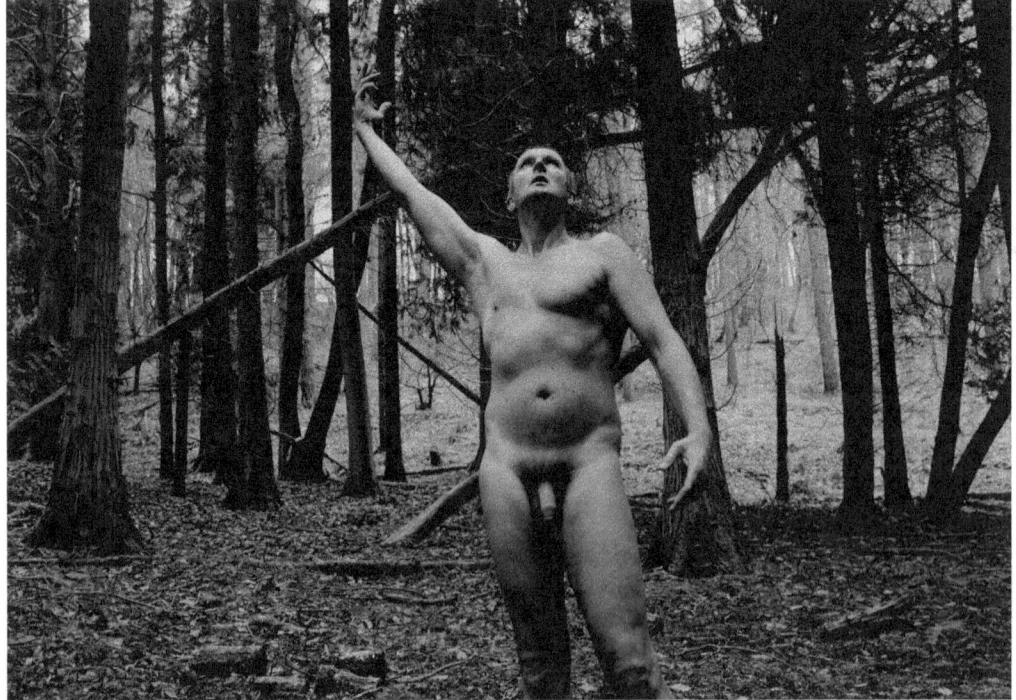

Abor Semper Vitae

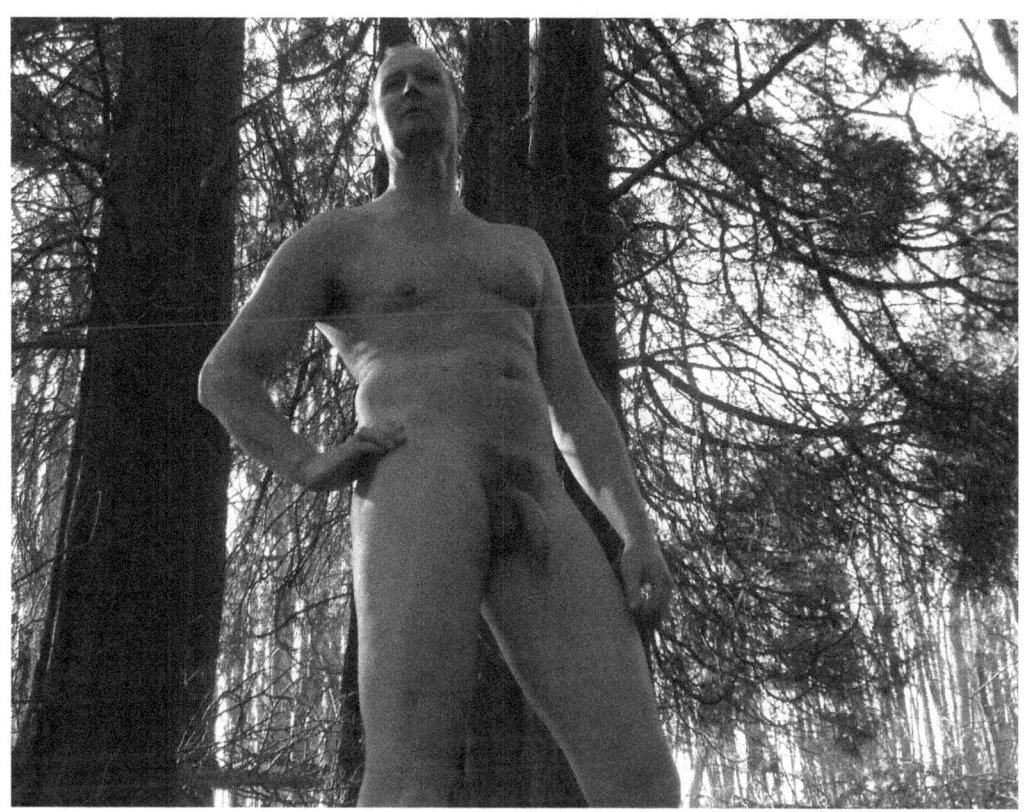

Terra Unedo Tempor

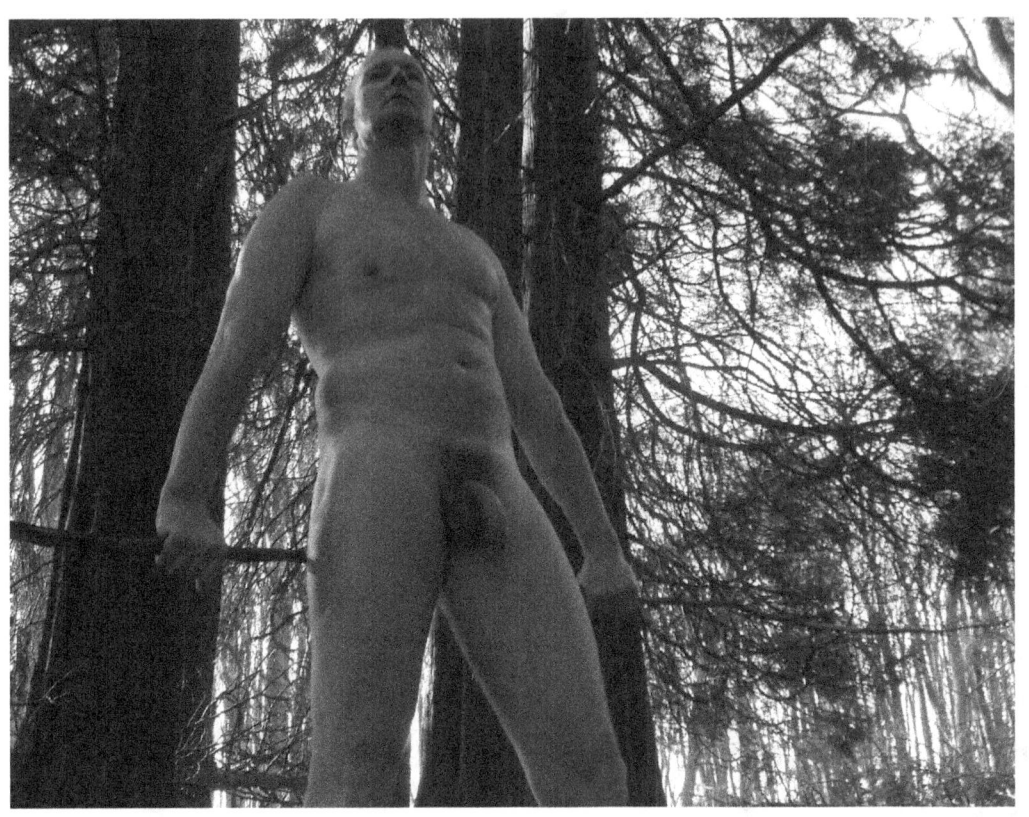

Terra Minimus

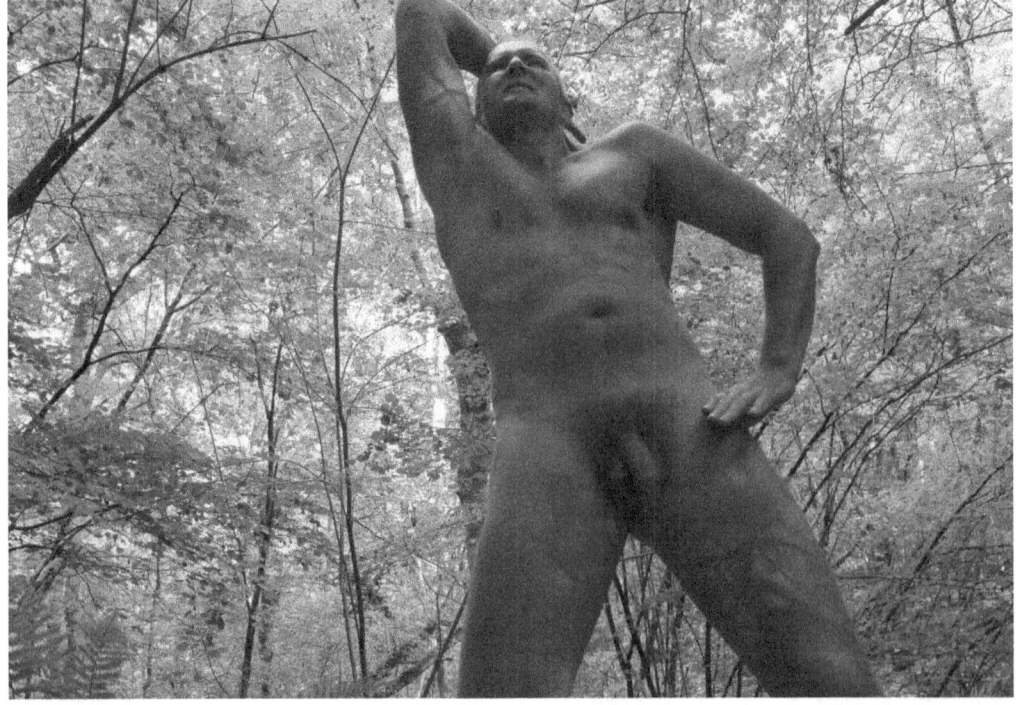

Elapse

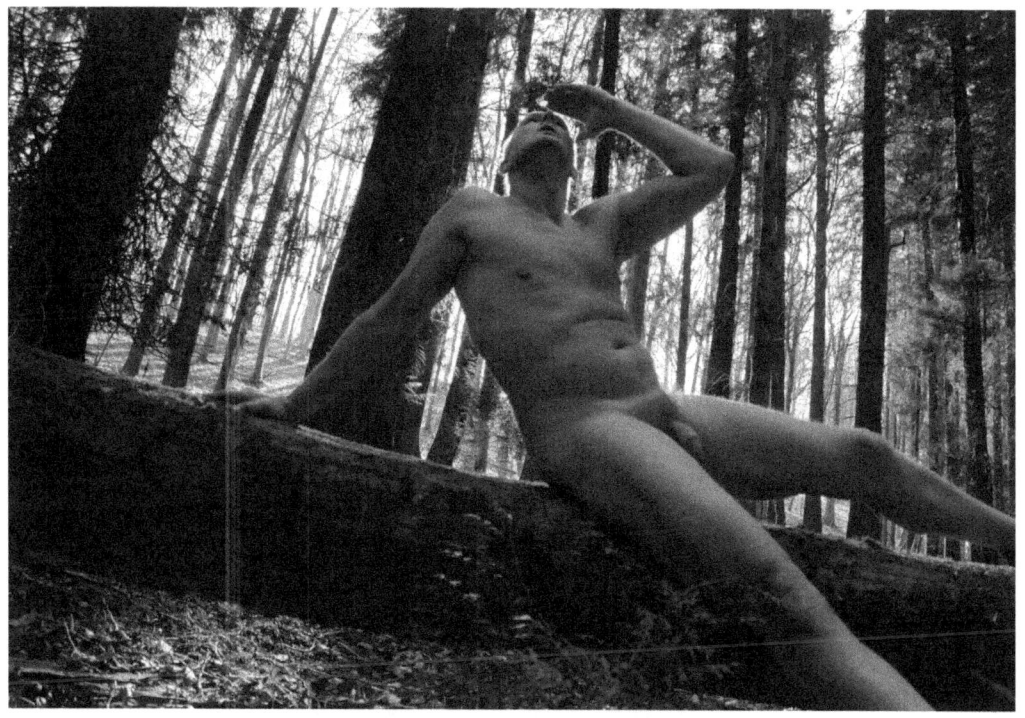

Re-Cognition

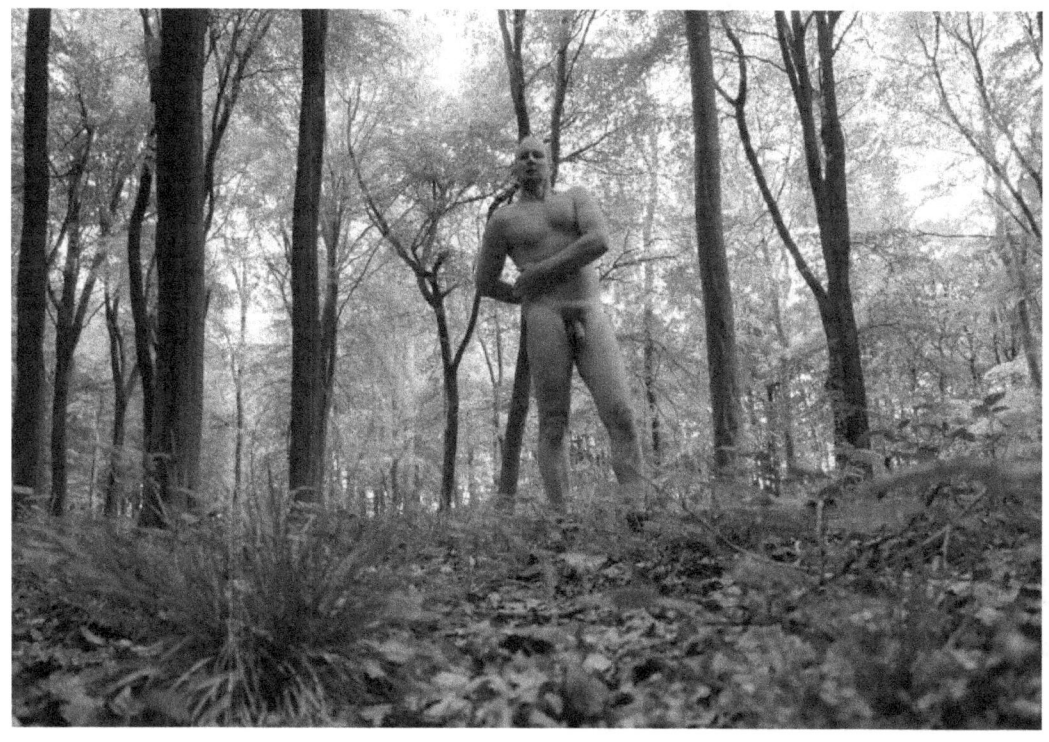

Fors

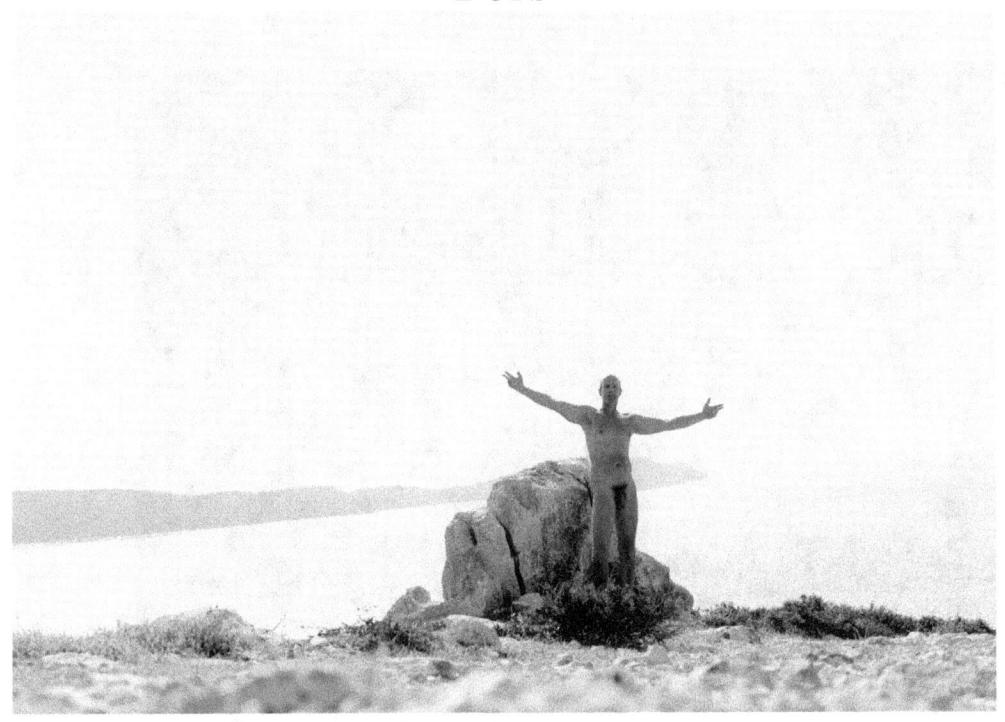

Castanum

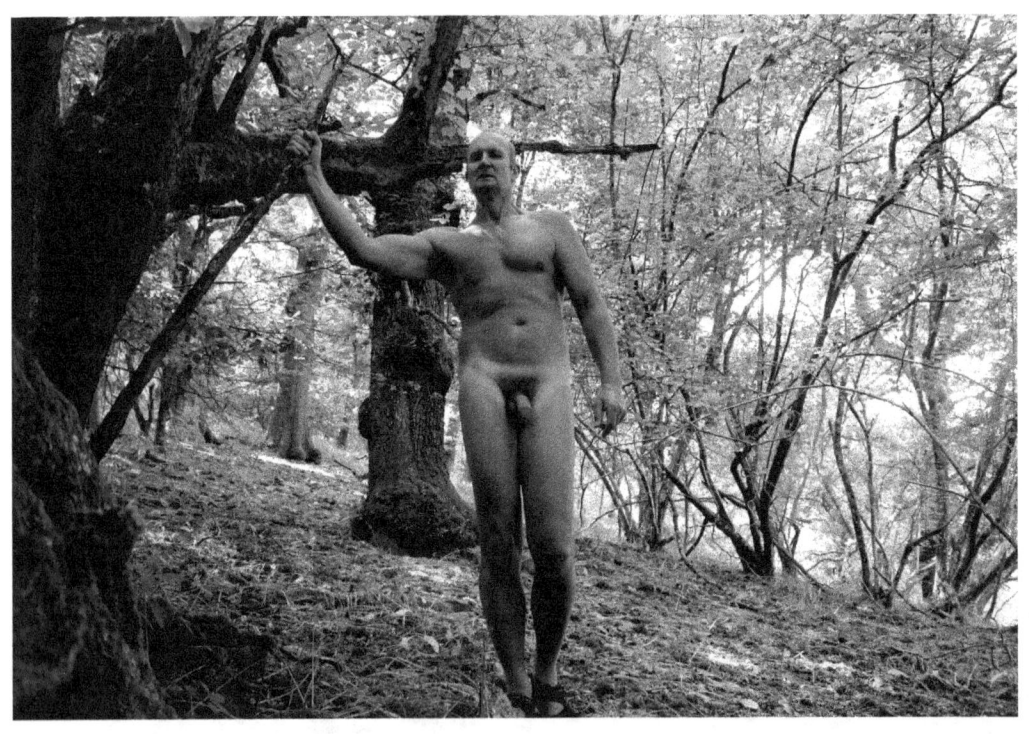

Elapse

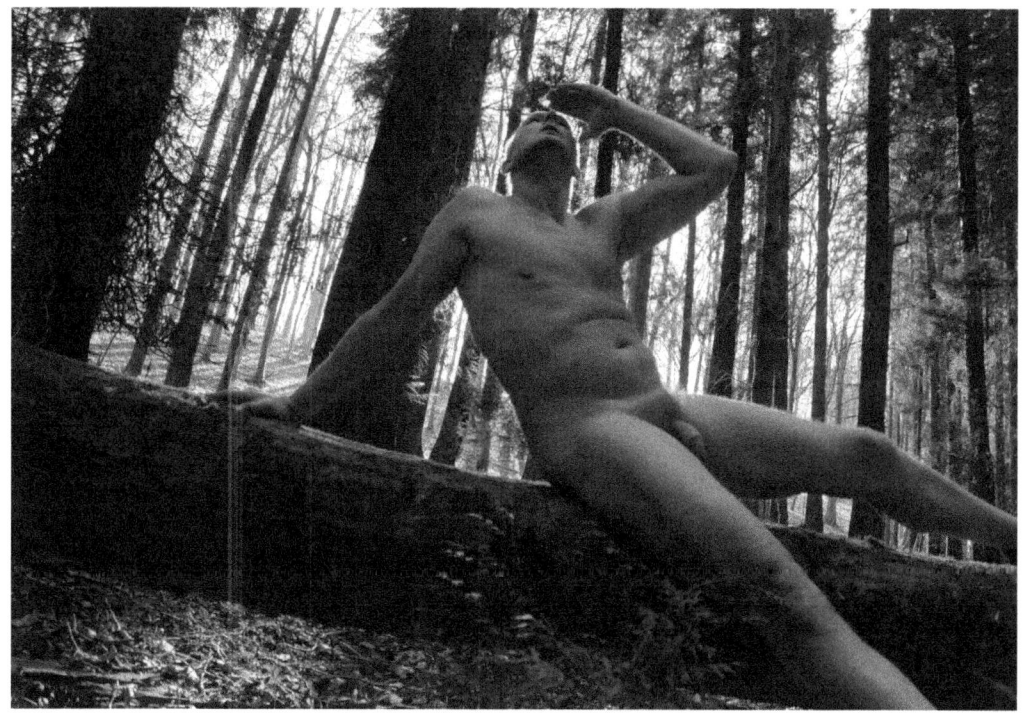

Re-Cognition

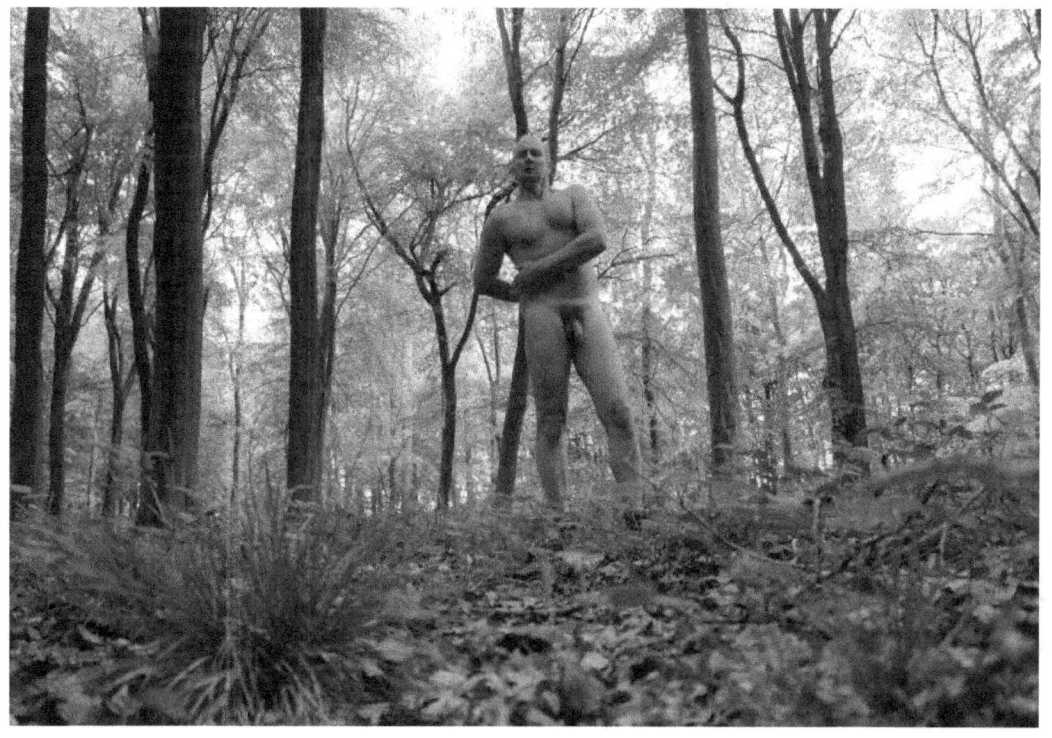

Fors

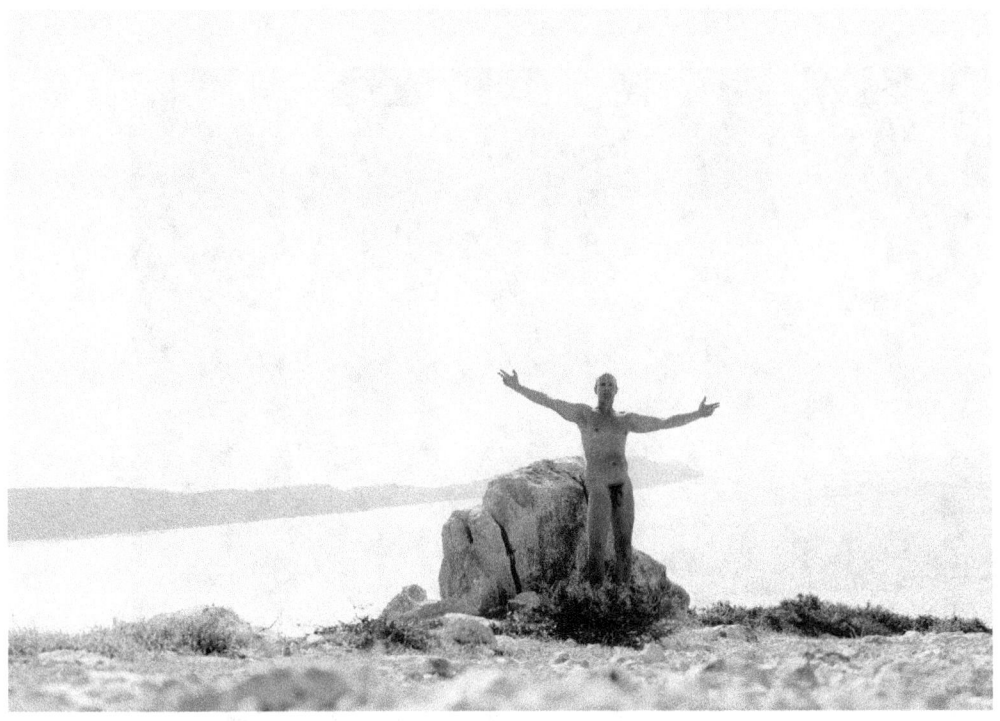

Castanum

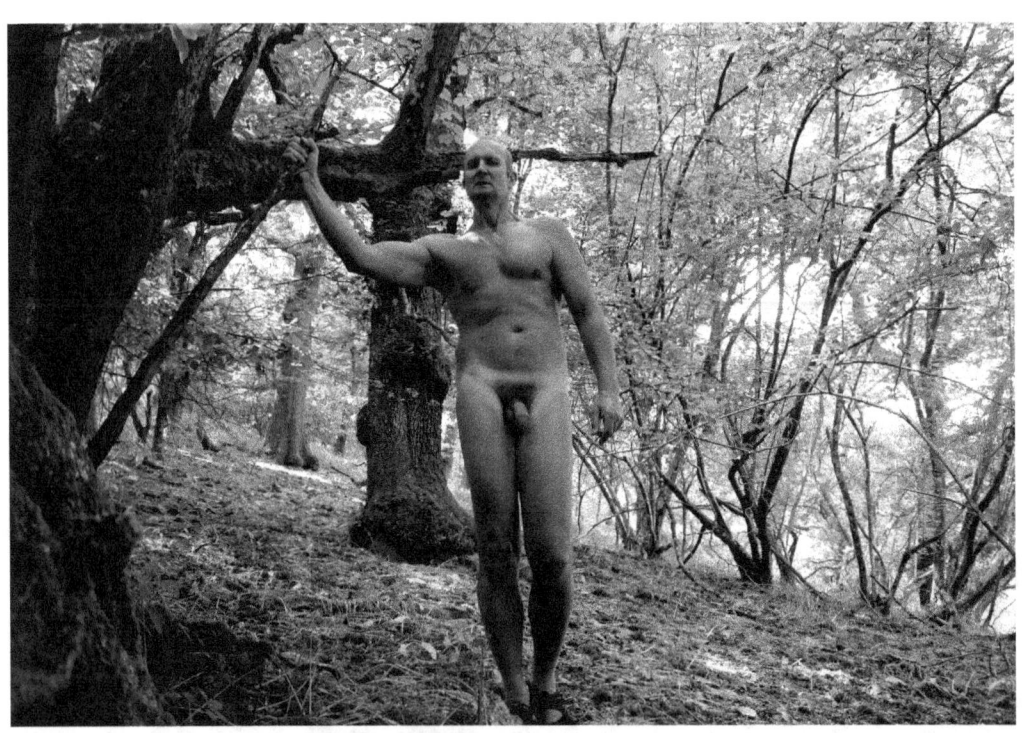

Castanus

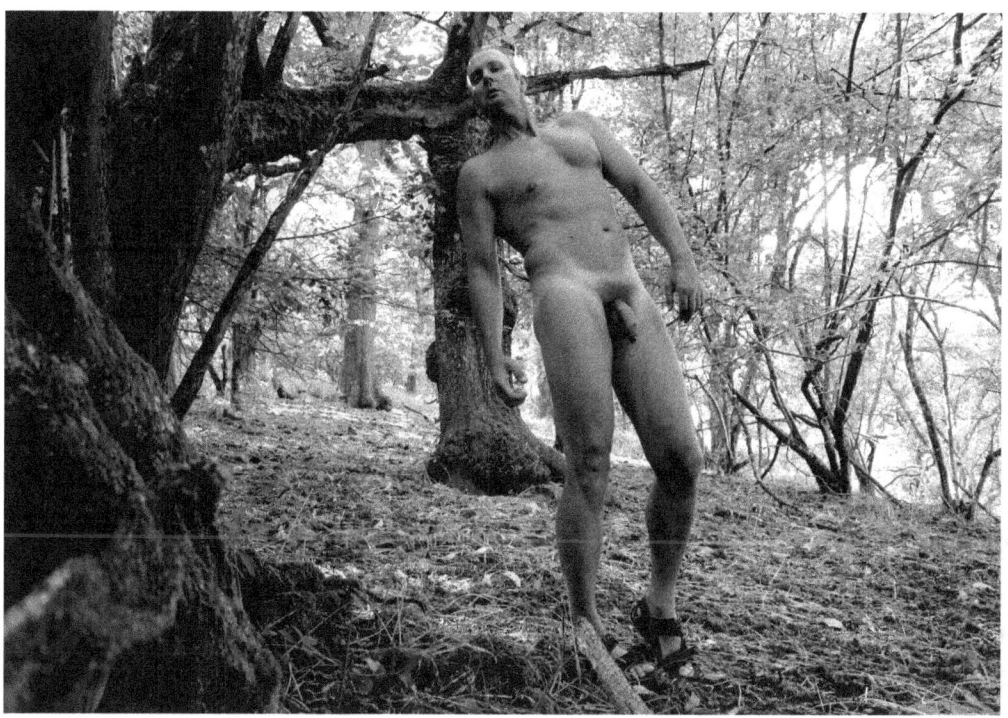

Juris Perdus

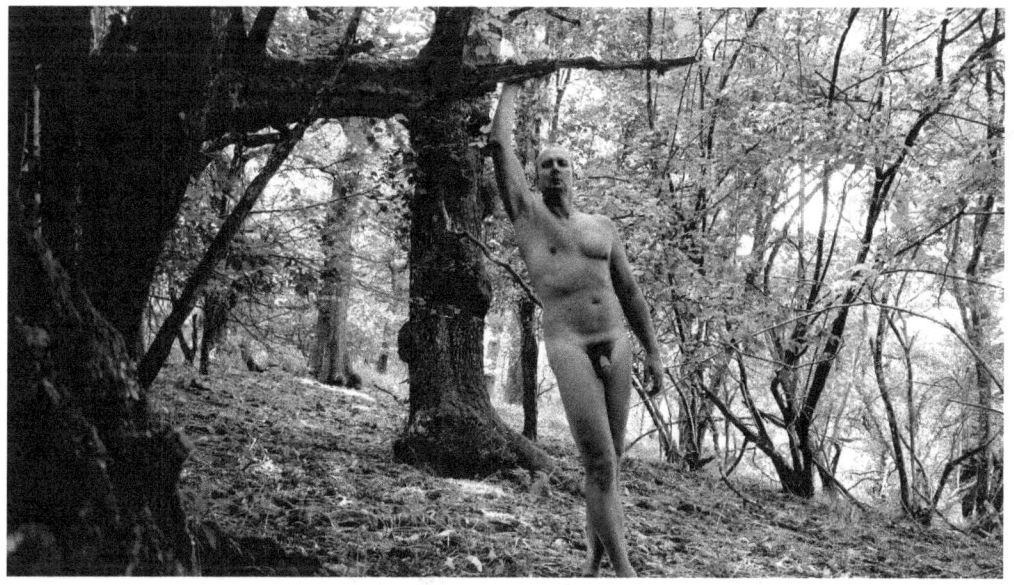

Gracium Evidus

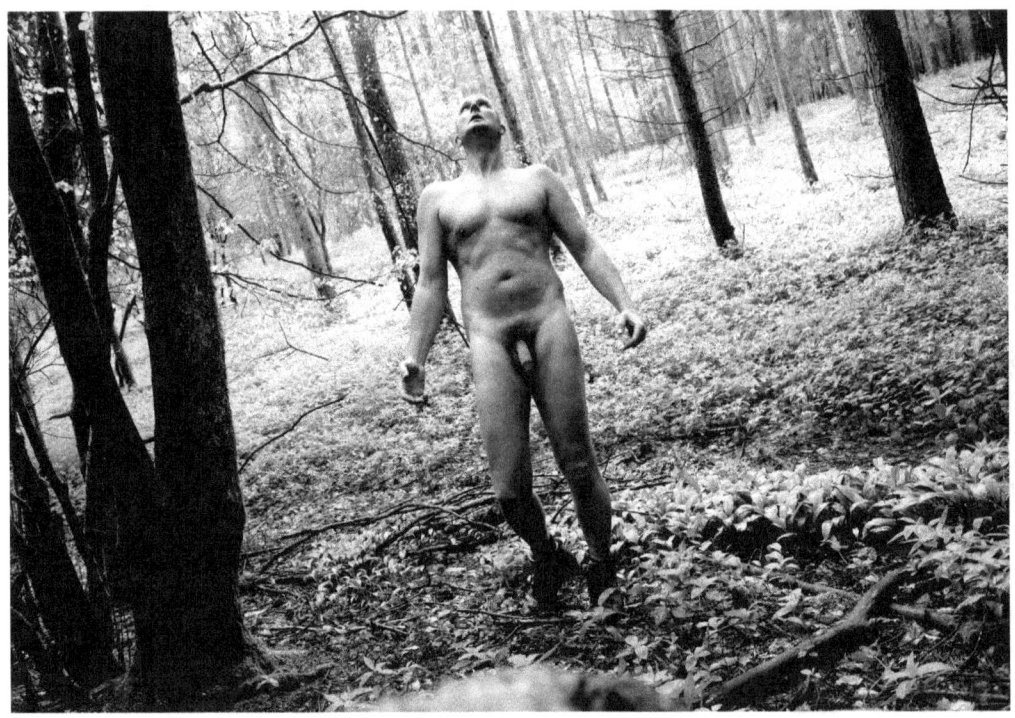

Flux

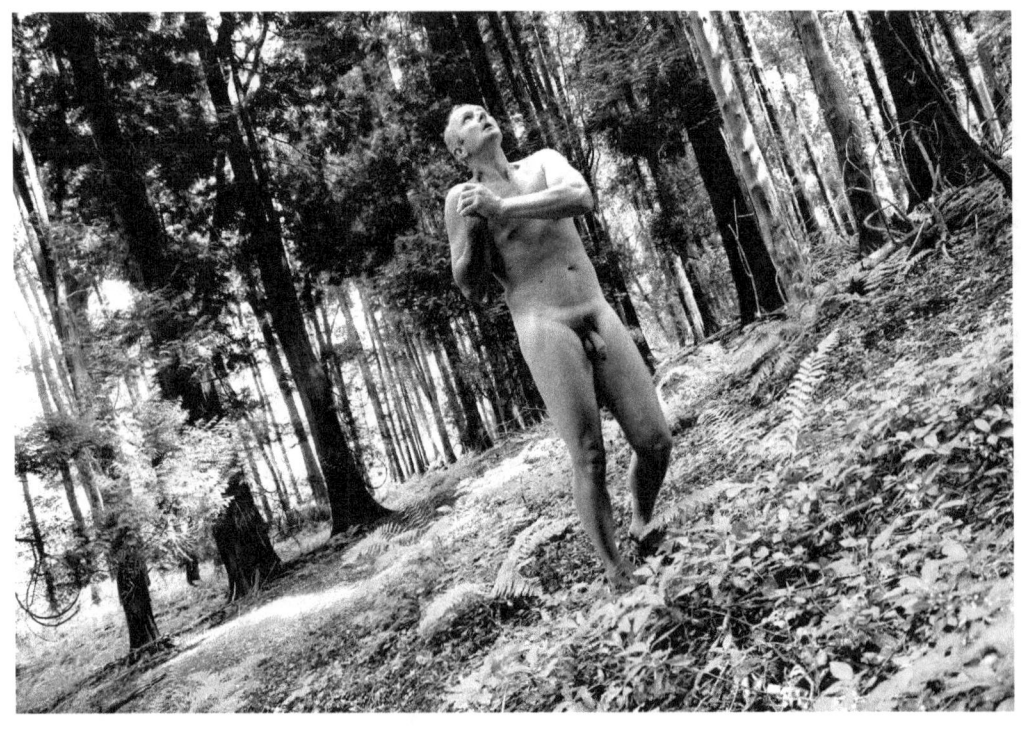

Surveillum

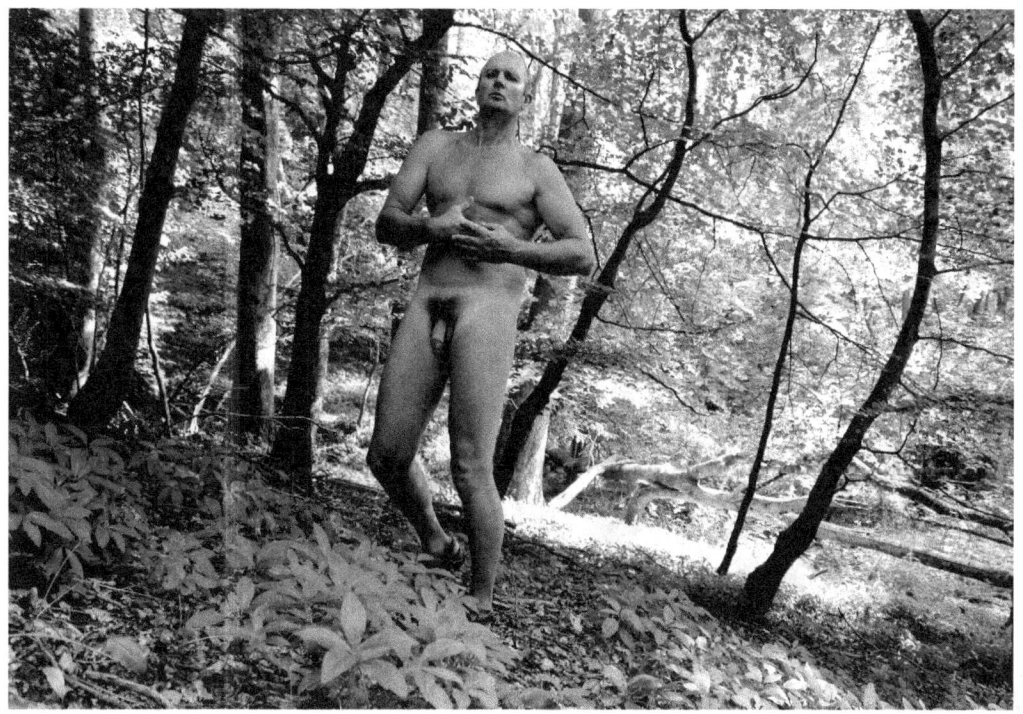

Terra Timidus

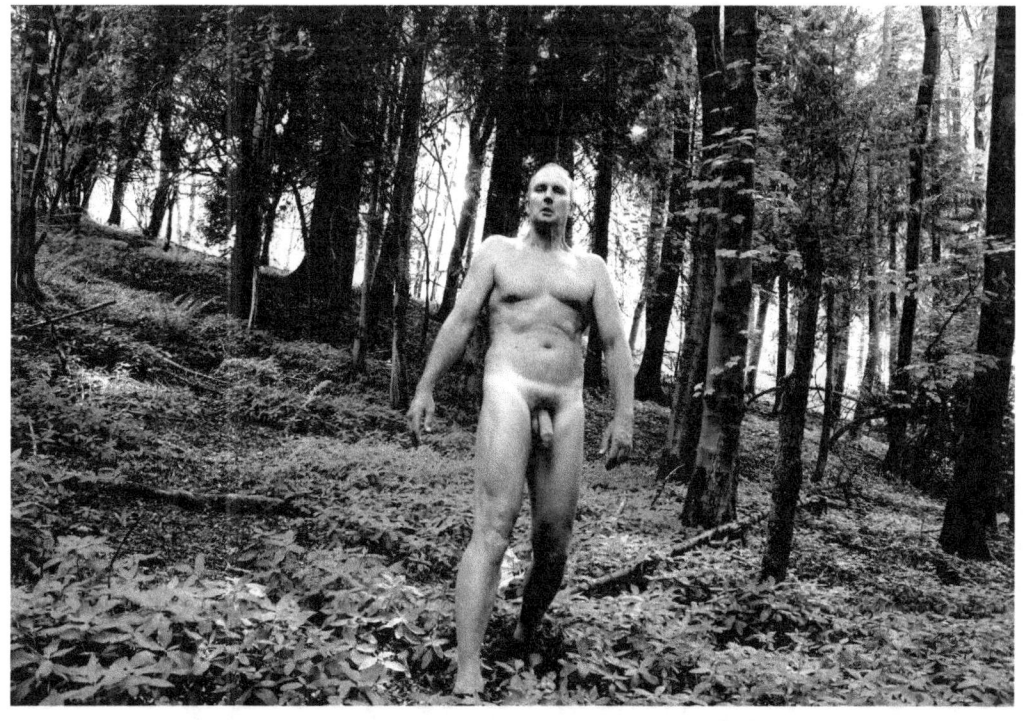

Inconclavius

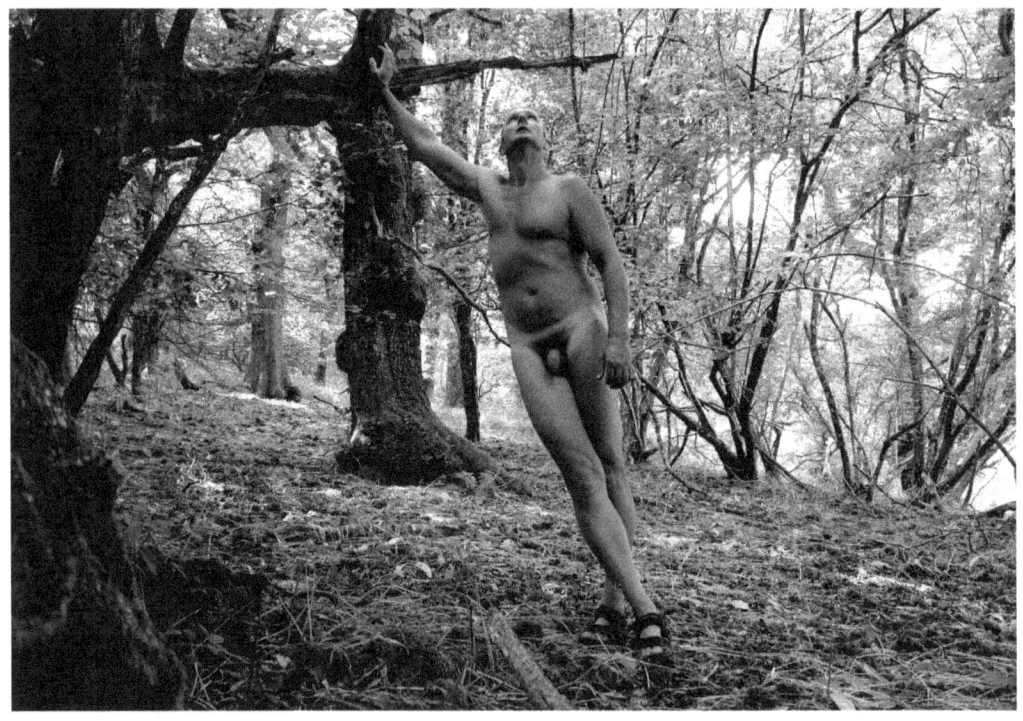

Rodaltus

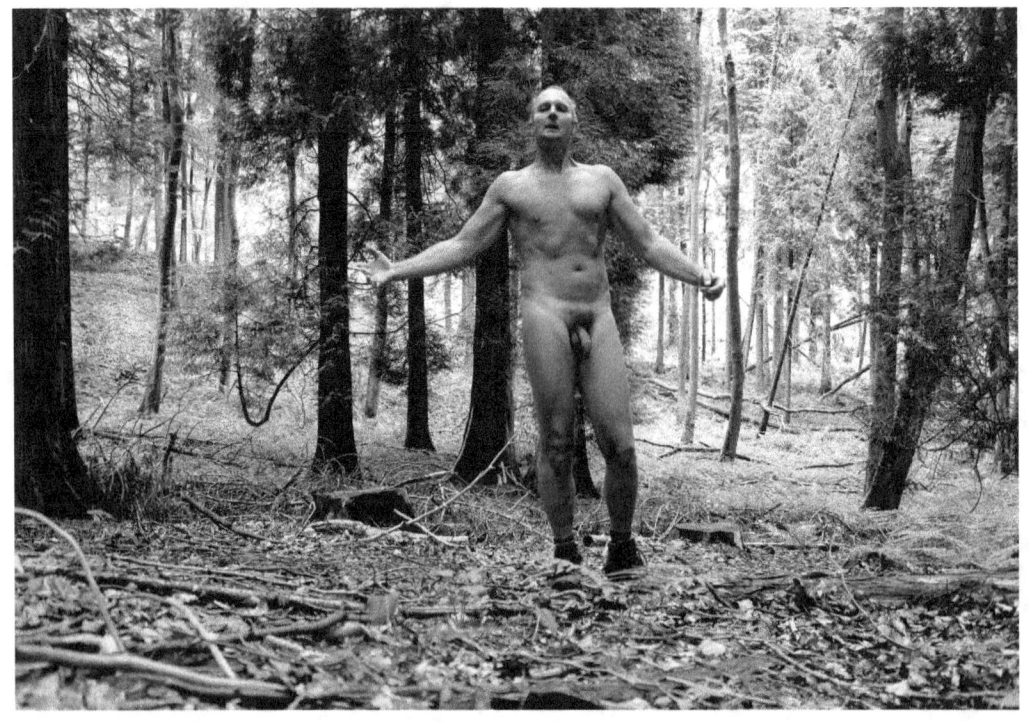

Axius

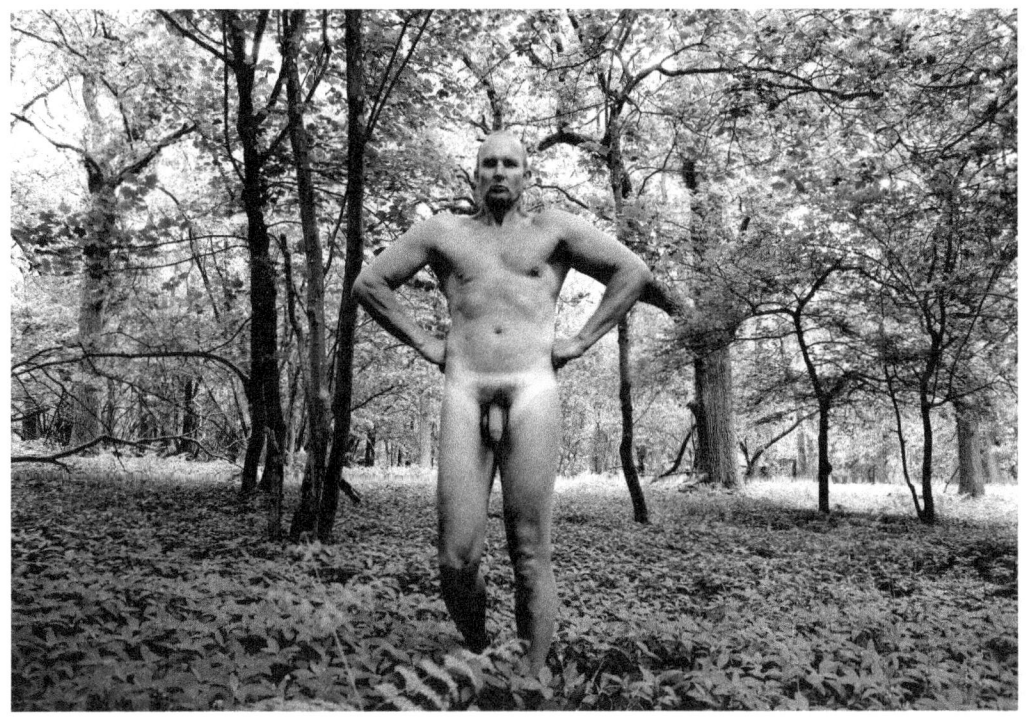

Non-Evadus

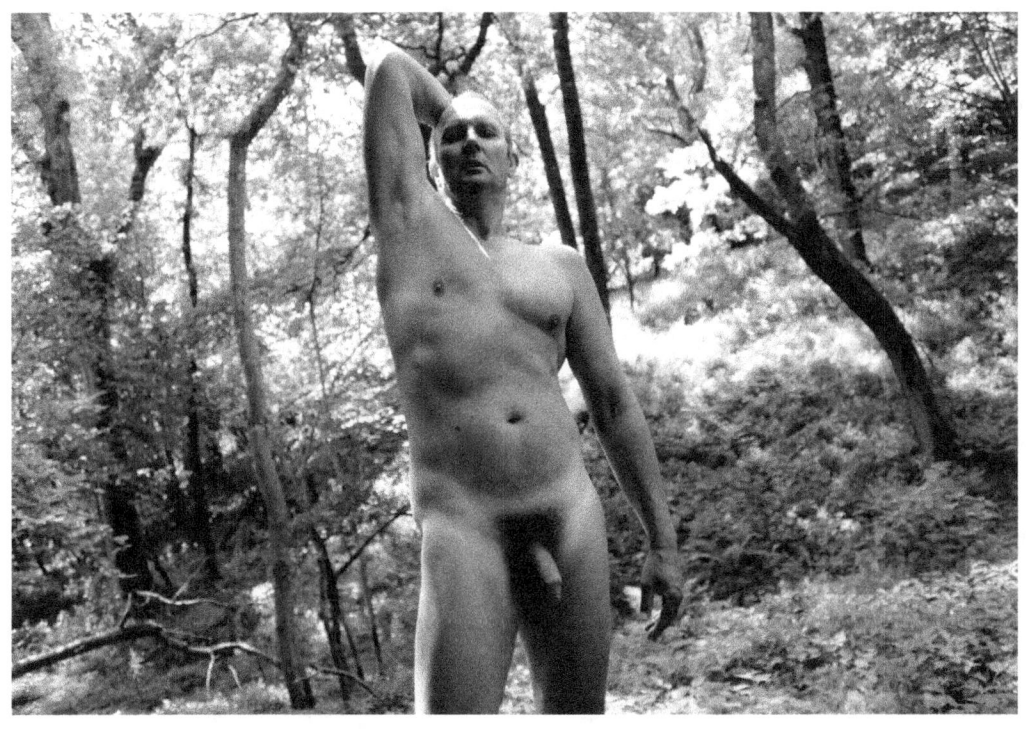

Gamus

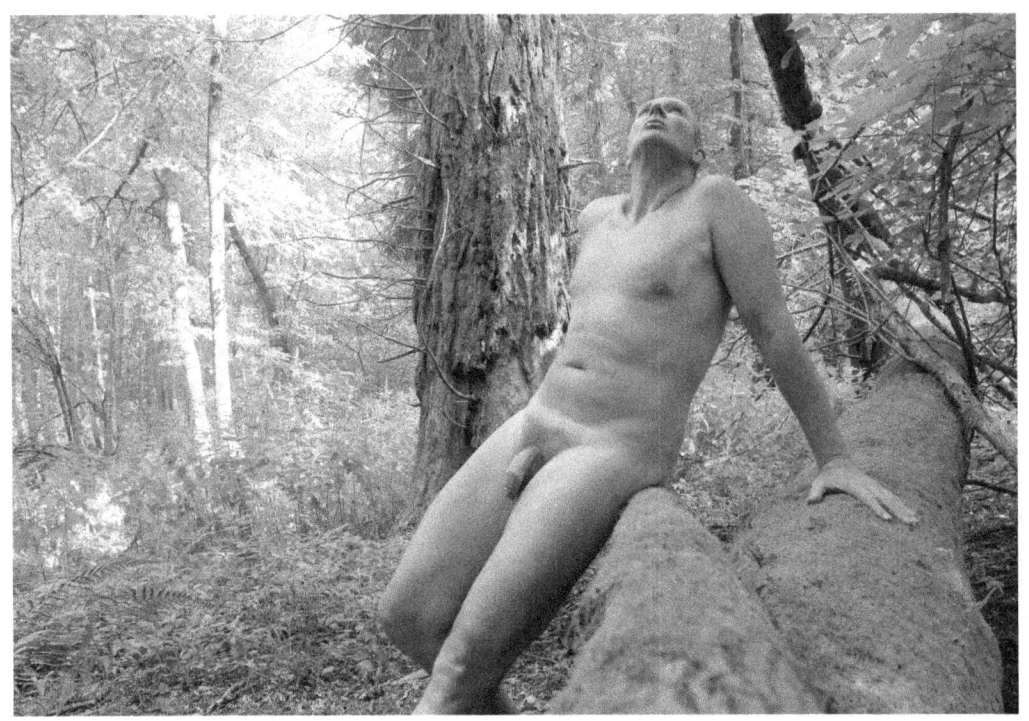

Regulio

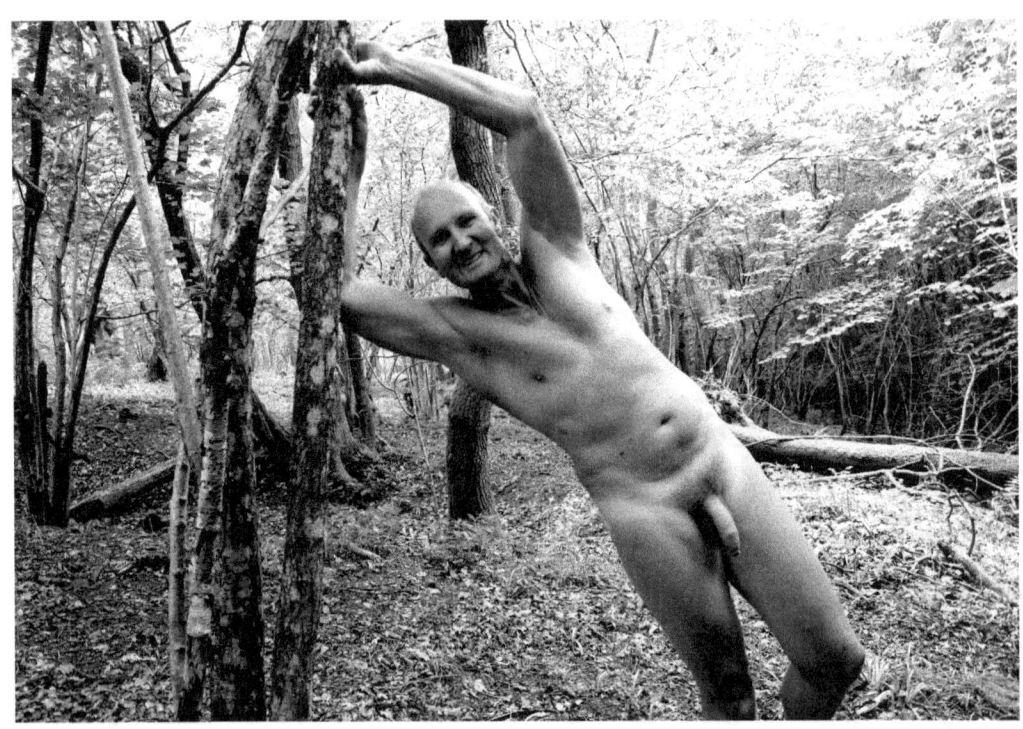

Retraction

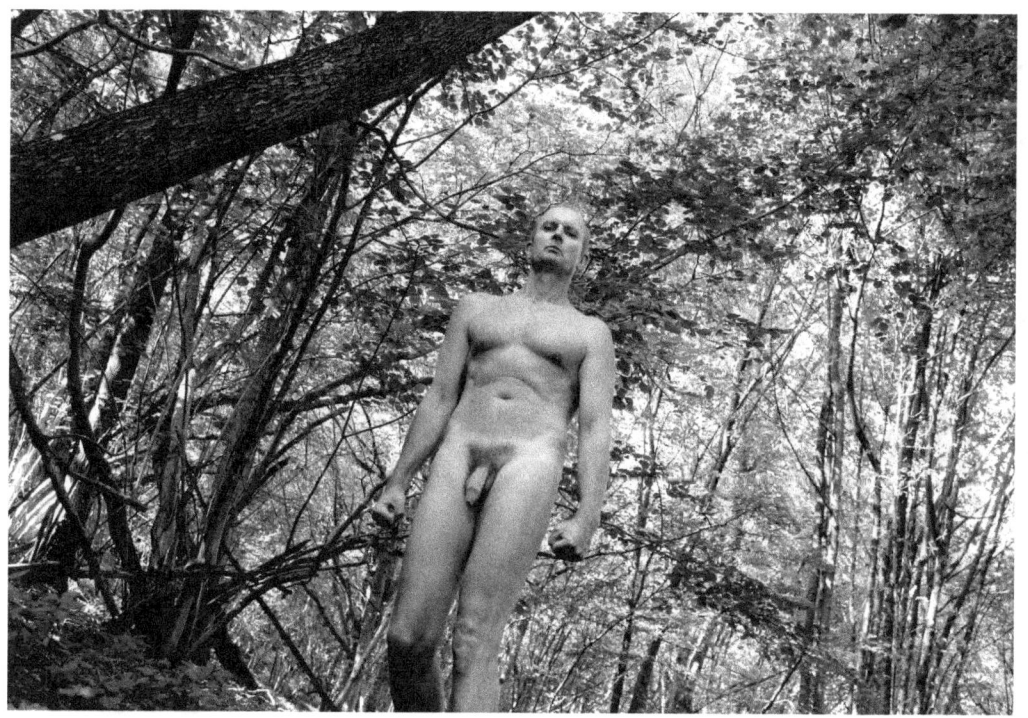

Expansion

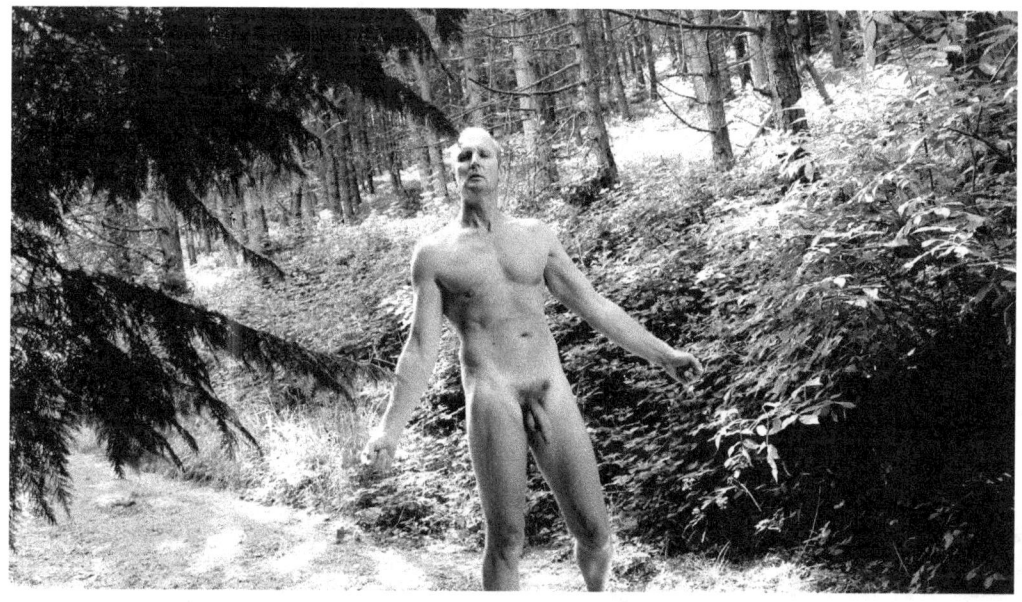

Completion

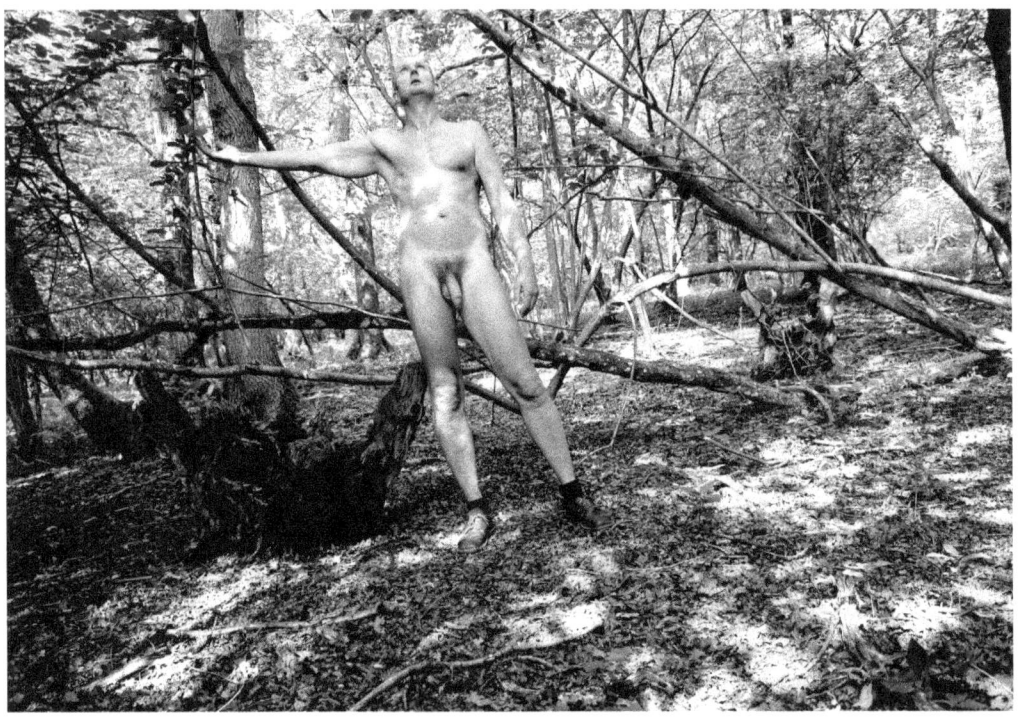

Reorientation

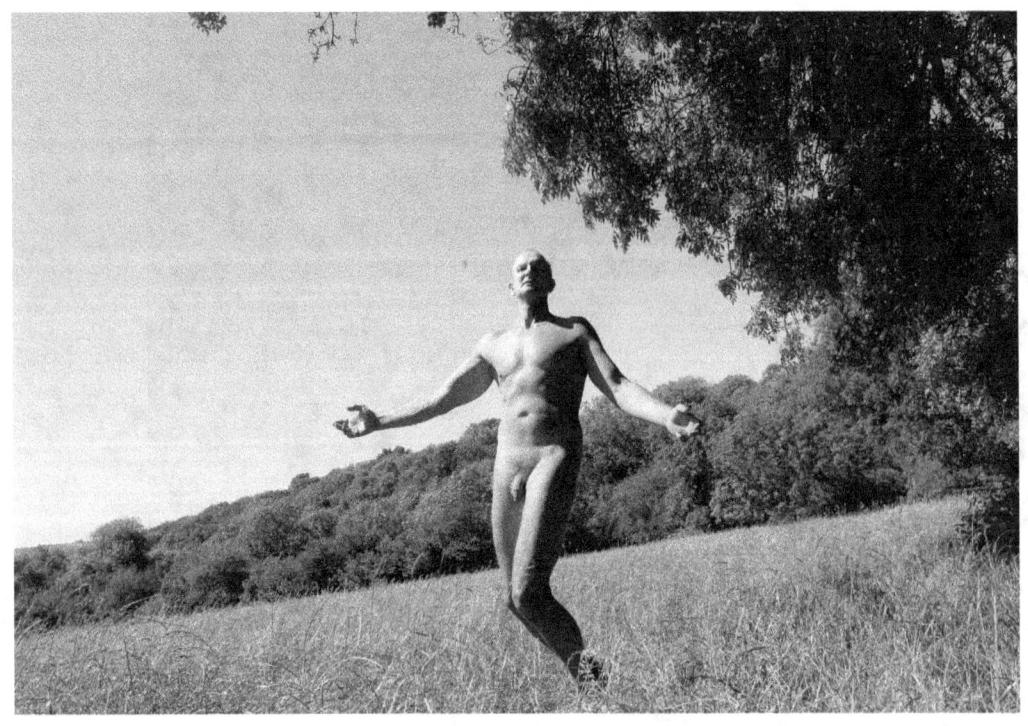

Relegation

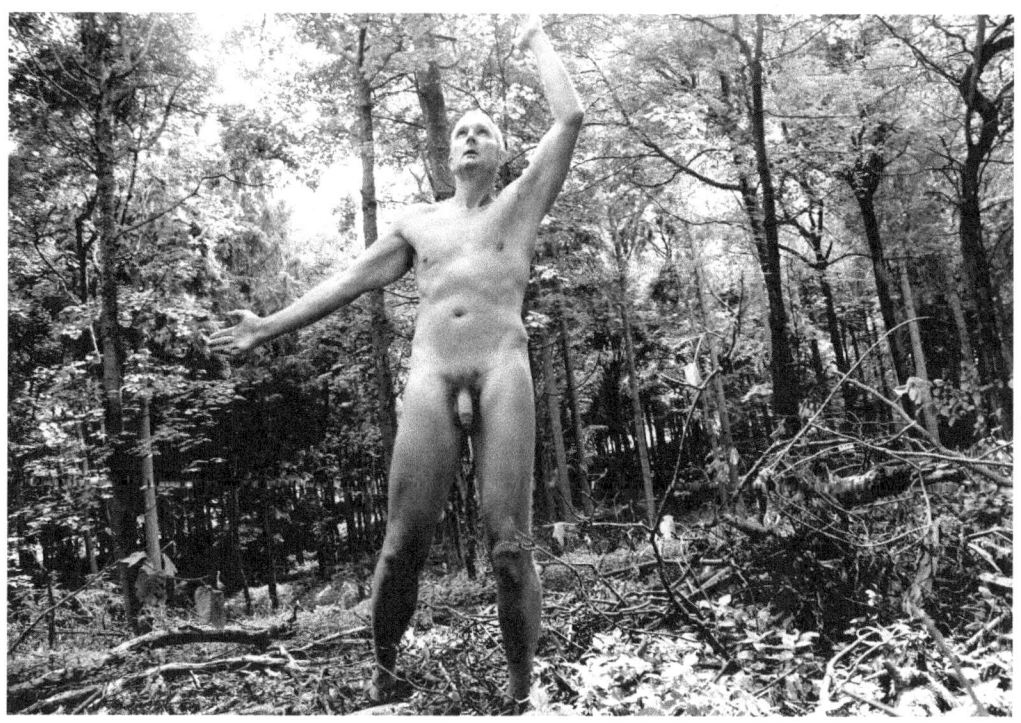

Absolution

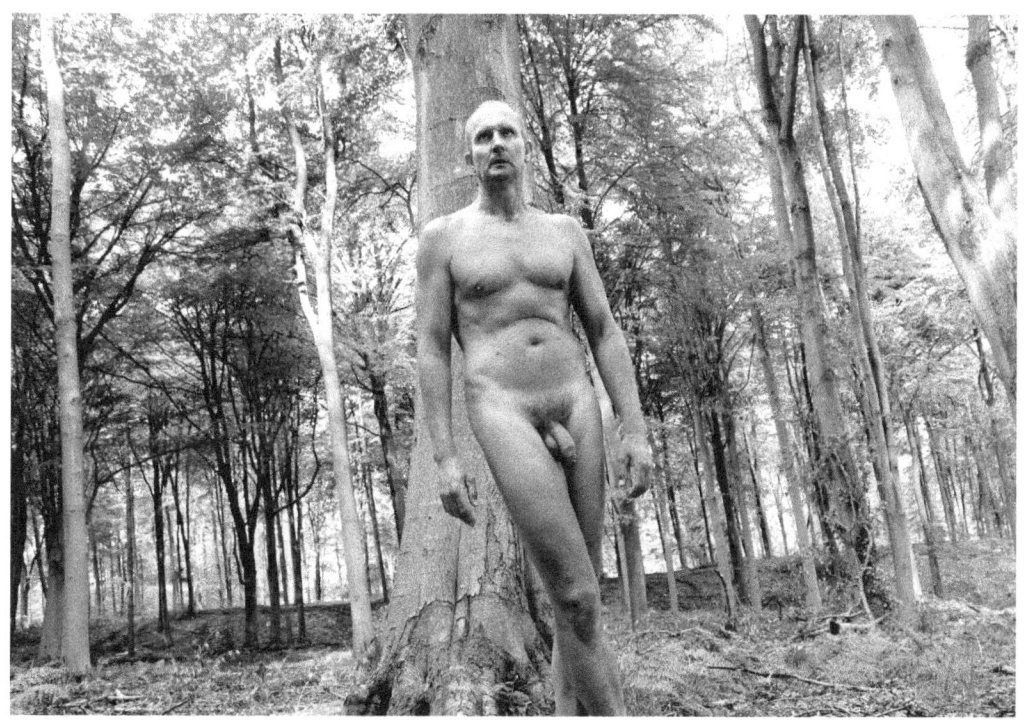

Nuncio

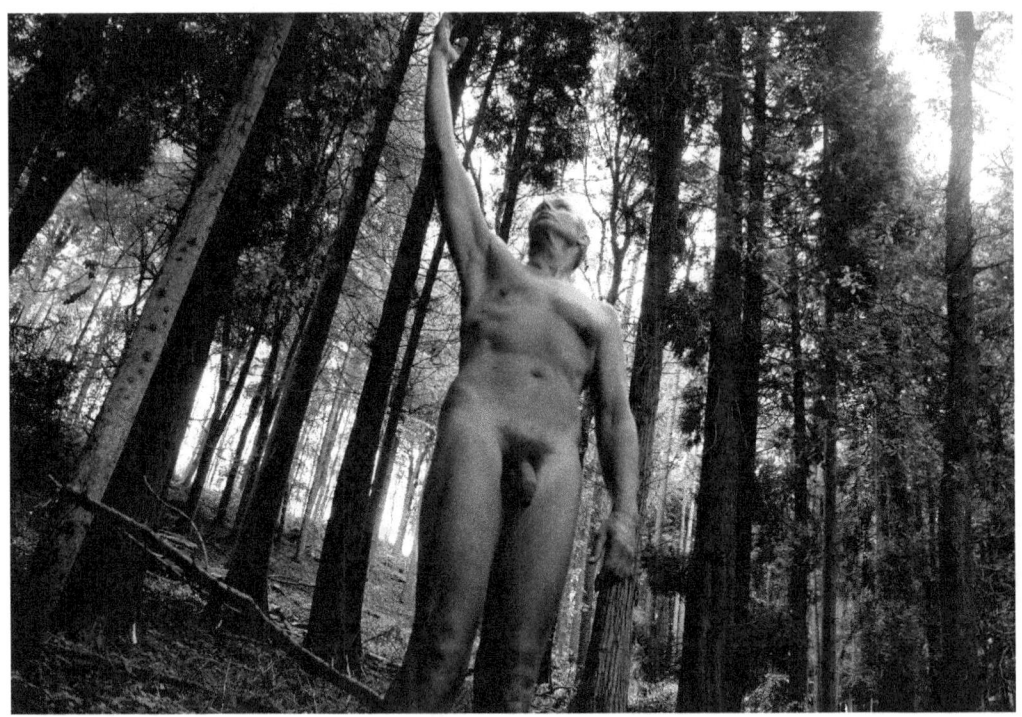

Espirtus

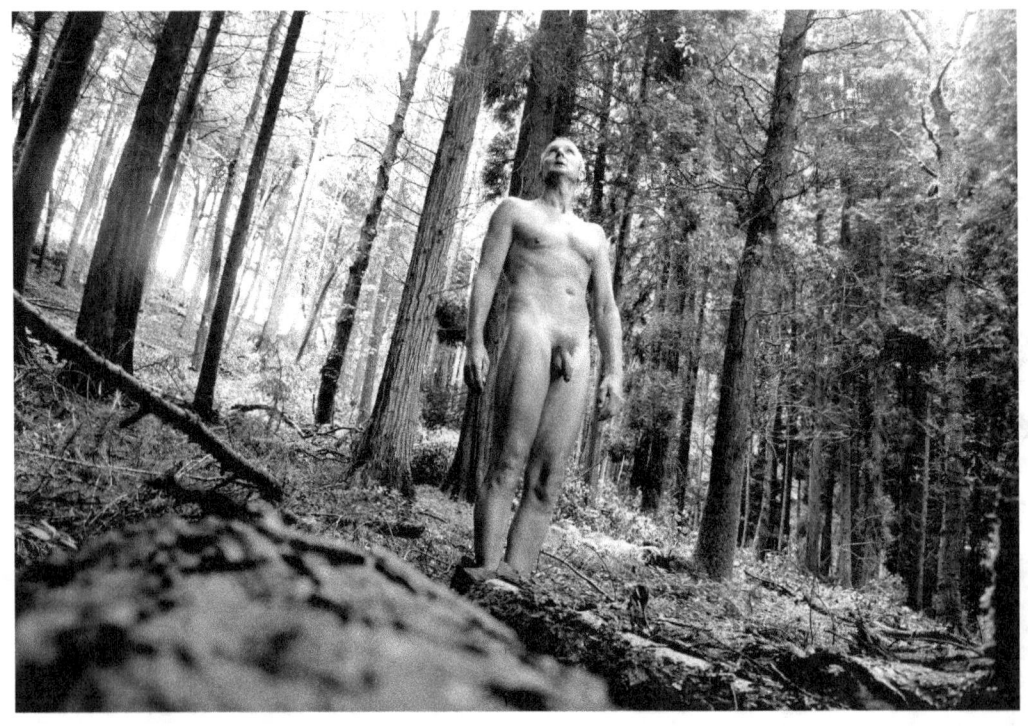

Callis Salvator

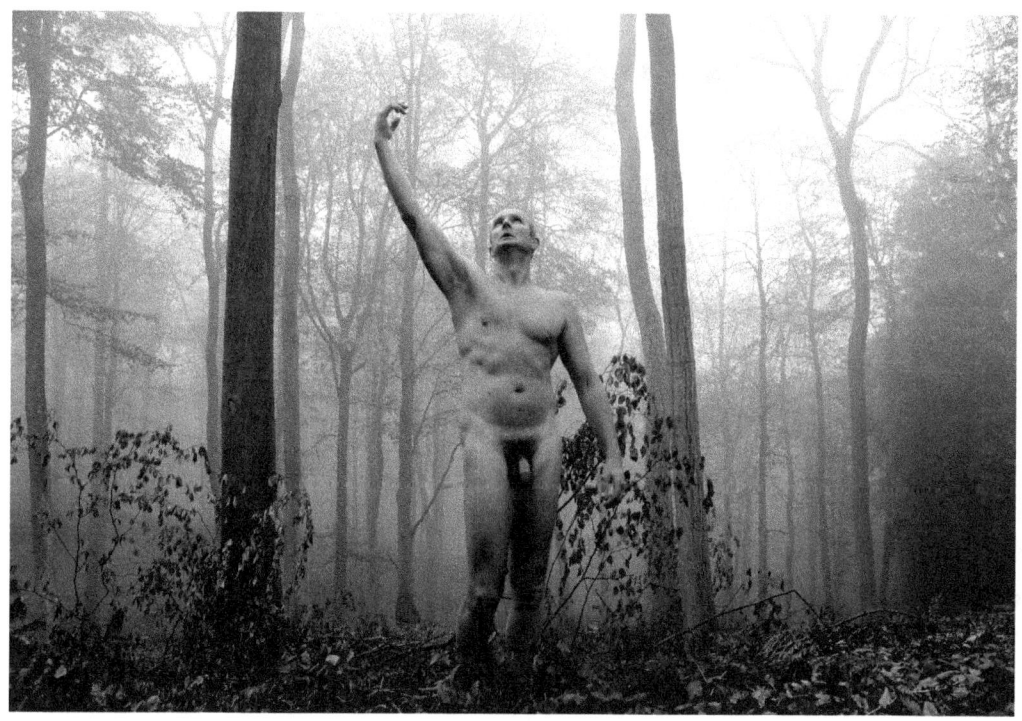

Callis Terminus

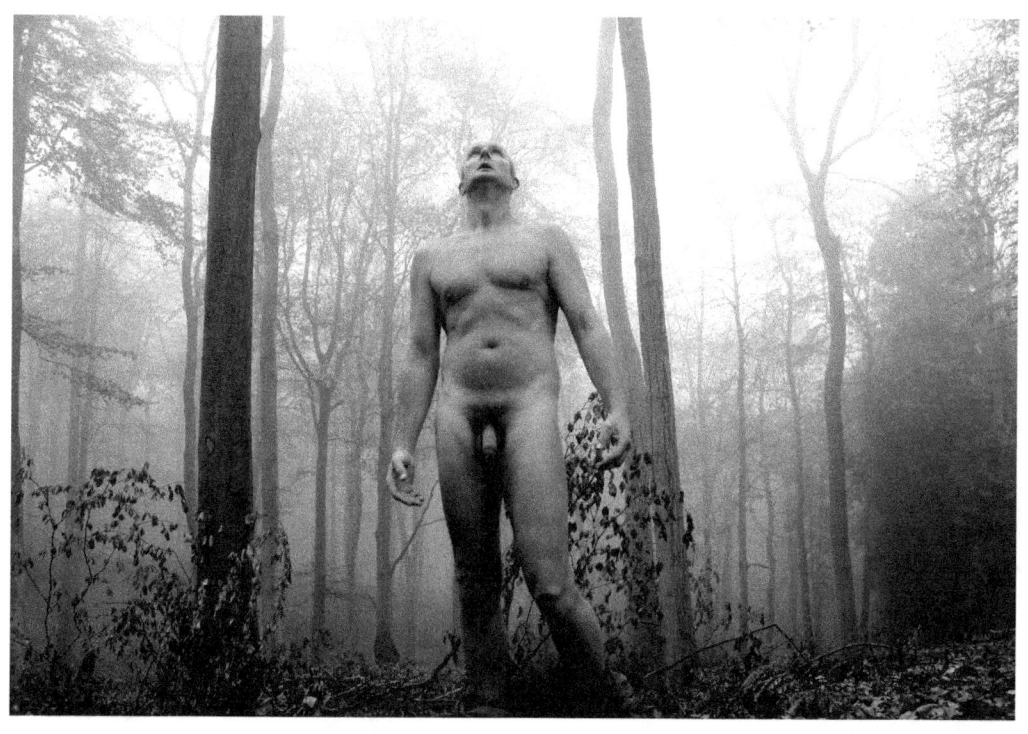

Callis Accipe

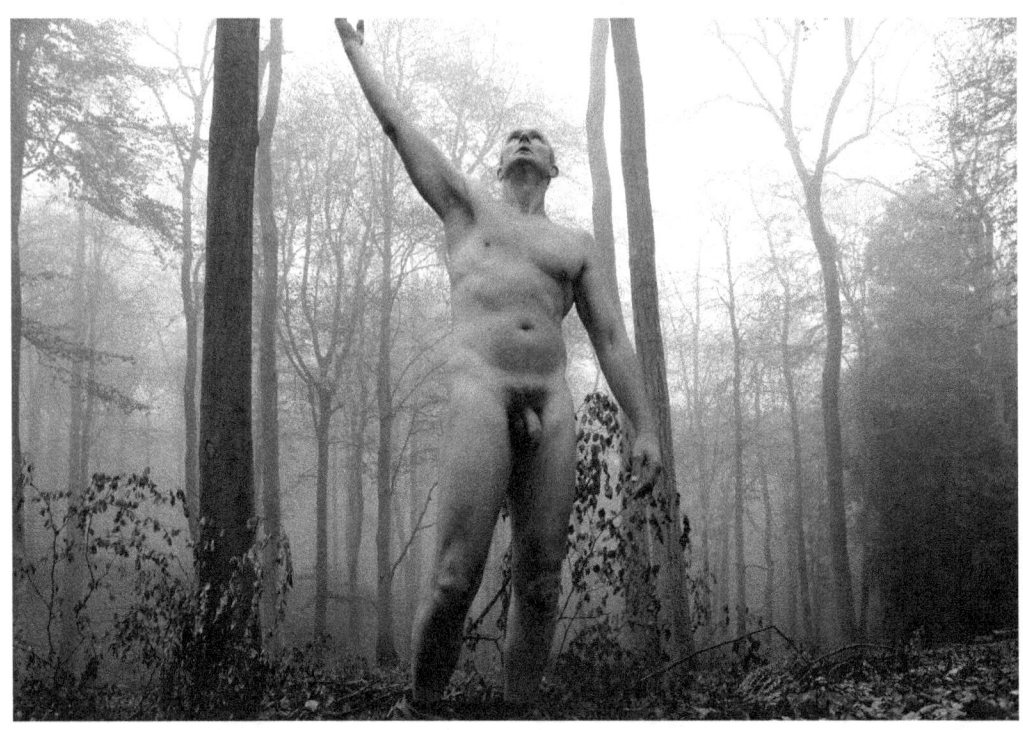

Arcturium

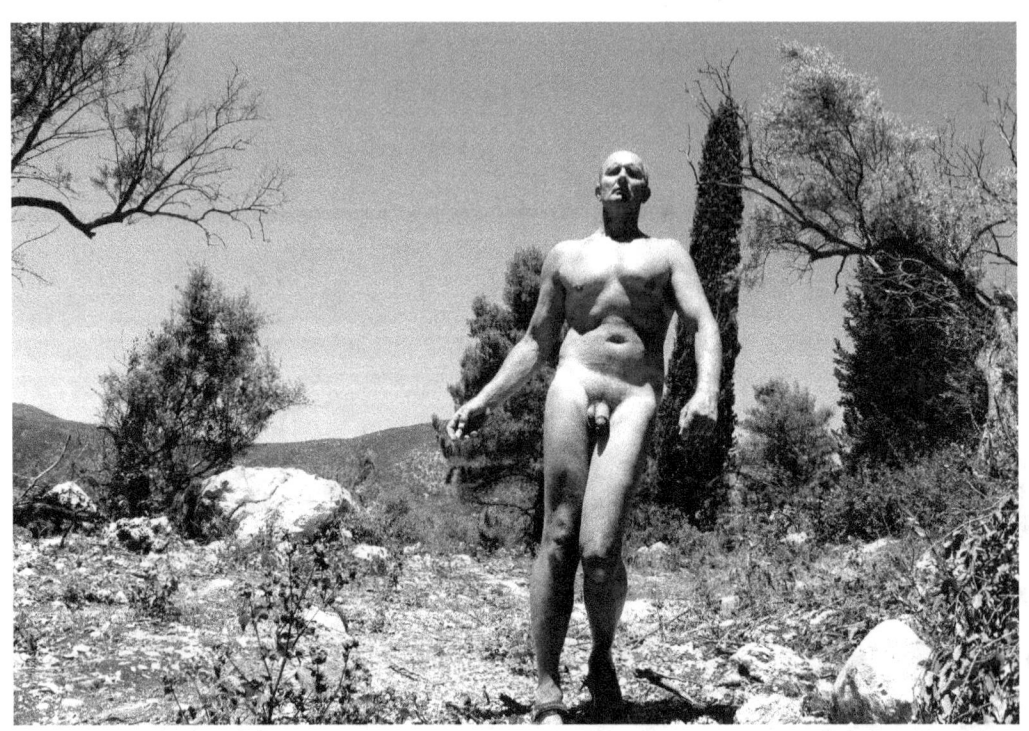

Retrium

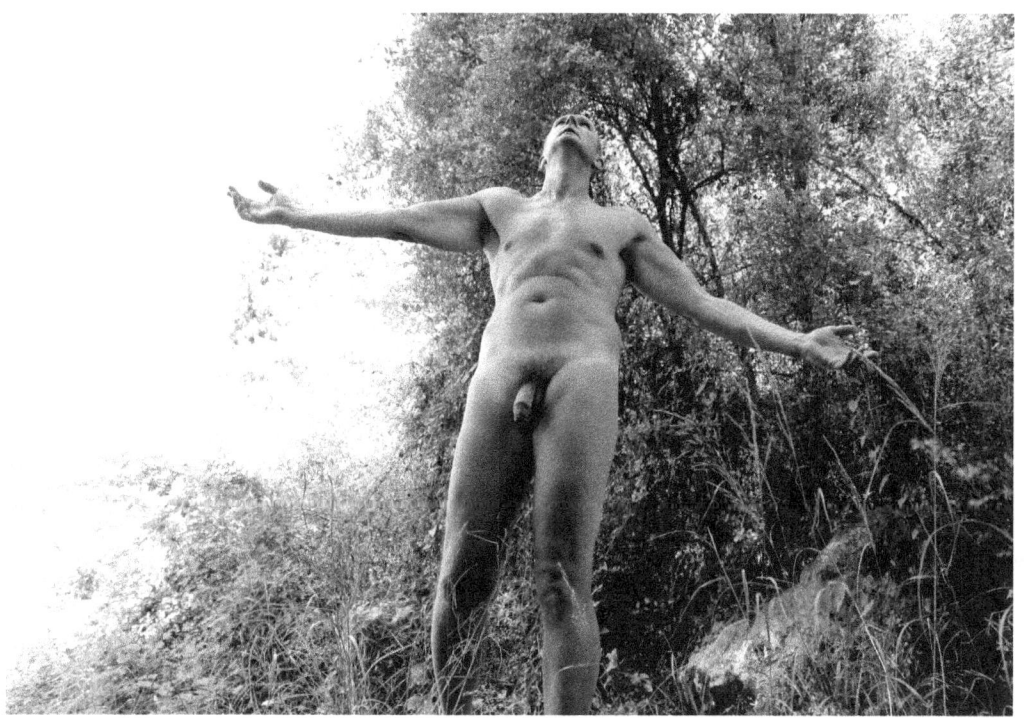

FINIS

www.ingramcontent.com/pod-product-compliance
Lightning Source LLC
Chambersburg PA
CBHW081907170526
45167CB00007B/3186